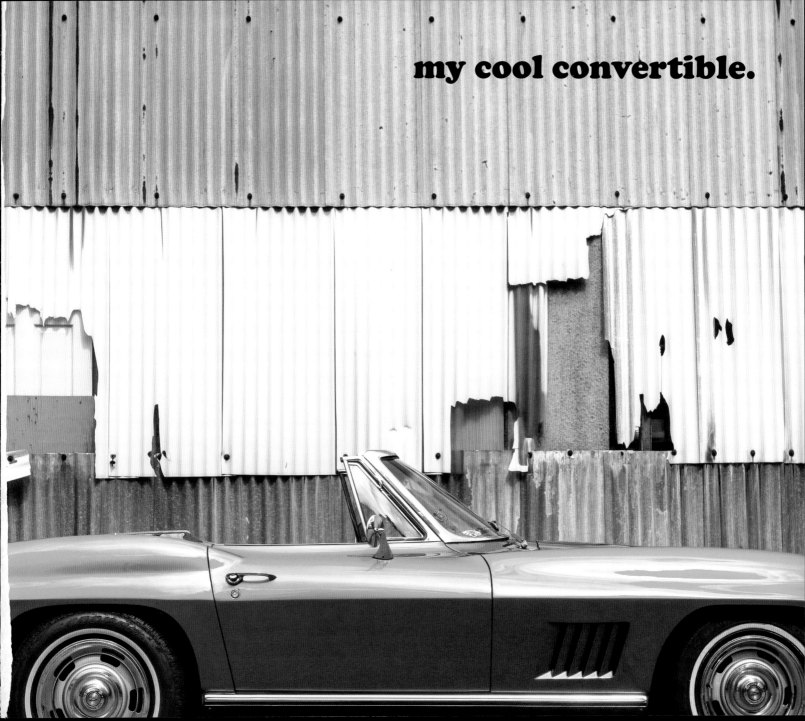

my cool convertible.

my cool convertible.

an inspirational guide to stylish convertibles

chris haddon

photography by **lyndon mcneil**

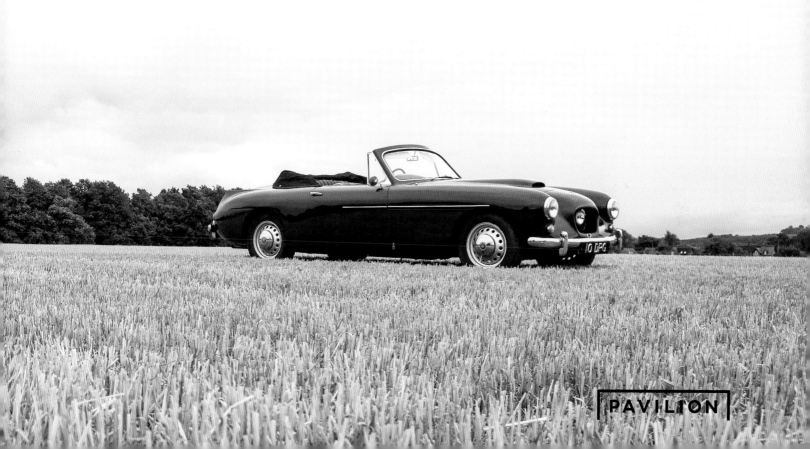

PAVILION

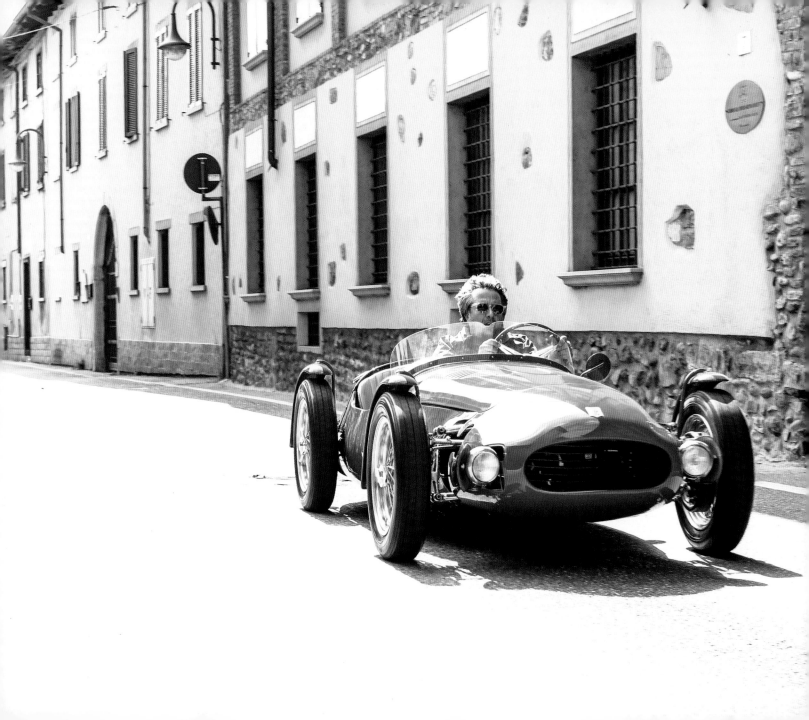

contents

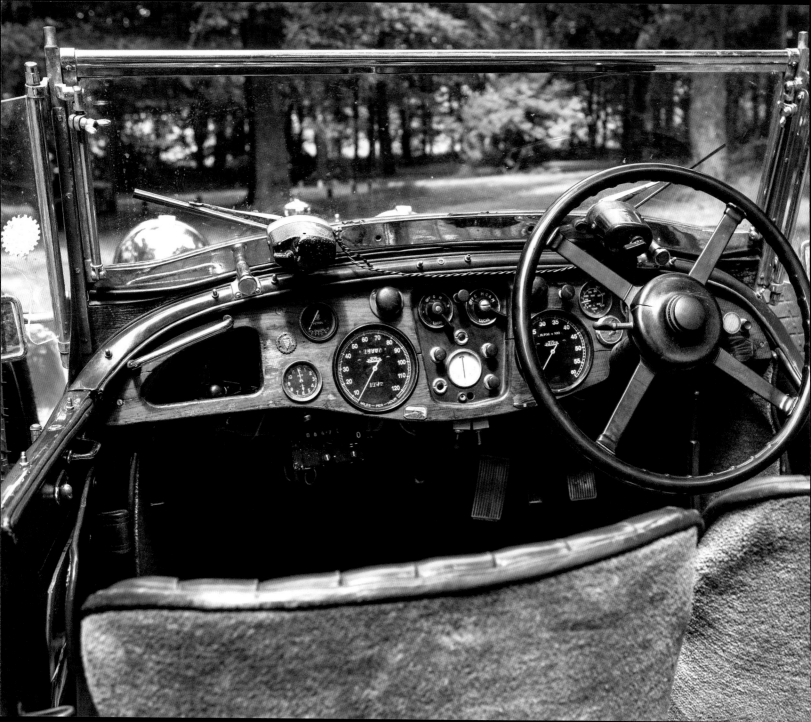

introduction

Convertibles: one of those rare situations where less most certainly means more. Given the choice, who wouldn't jump at the chance of owning a convertible – especially if it hails from a bygone era of motoring? Such vehicles are seen by many as a way to truly experience the sights, sounds and aromas of driving whenever the opportunity should arise; as opposed to spending time in a near soundproofed and hermetically sealed vehicle that leaves you devoid of several senses.

During the pioneering days of motoring there was little chance of avoiding your surroundings – quite literally. Being caught out on an inclement day often resulted in a full-frontal barrage you wouldn't forget. After all, those were the early days of automobiles, vehicles that in essence were just derivatives of horse-drawn carriages and retained much of their minimalist design. Your only defence against whatever the weather hurled at you was the clothes you were wearing – which led to many shrewd manufacturers tailoring garments made of heavyweight fabrics specifically for wealthy motorists. Retractable fabric hoods, similar to those on landau carriages (a four-wheeled convertible horse-drawn vehicle), didn't make an appearance until the late nineteenth century. Despite being far from weather-tight, this was nonetheless seen as an improvement. But as drivers spent ever more time behind the wheel, on what can only be described as basic roads, their demands for higher levels of creature comforts increased. As mass-production techniques enabled the average car buyer to afford the luxury of a weather-tight roof, it spelled the death knell for fully open cars. Yet, as is often the case, it takes the loss of something for you to really appreciate what you had.

Things took a significant step forward in 1934, with the range-topping Peugeot 601 Eclipse – the world's first car to have a self-storing folding metal roof, giving both the driver and occupants the best of both worlds. Within these pages you'll find prewar examples like a Lagonda M45 that competed in the 1936 Monte Carlo Rally and a Frazer Nash-BMW – the most valuable car featured – that was taken round the Brooklands circuit in 1937 as soon as its first owner got his hands on it. The widespread introduction of power-operated hoods was seen during the 1950s on cars such as the Cadillac 62 Series, featured in the opening chapter, 'treasured' – meaning no longer did drivers have to vacate their seat, whenever the weather necessitated it, in order to tend to the roof. Air conditioning tried in vain to negate the need for convertibles, as did sunroofs, targas and T-tops – yet the drivers' thirst for full open-top, wind-in-your-hair motoring never ceased, leading to specialist conversion companies like Crayford

turning out convertible models of classics like the Ford Cortina and Wolseley Hornet. The 1980s – sometimes referred to as the decade that taste forgot – spawned open-top versions of models like the Talbot Samba and the Reliant Scimitar; who would have thought then that such vehicles would now be much-coveted collectors' items?

my cool convertible, aside from being an opportunity to include a plethora of cars that didn't quite make it into *my cool classic car* in 2012, lifts the lid on the world of open-top motoring; its aim is to explore the rationale behind each owner's choice of vehicle and why it's become such an important part of their life. However, in line with my previous titles from the *my cool...* series, the criteria for inclusion is not focused on speed or value alone. Instead it's the lines, details, design aesthetics and emotive feeling generated that won me over, showcasing automobiles that embrace the personalities of manufacturers, as well as social trends at the time. Whatever opinion you may have of the cars that grace the pages of *my cool convertible*, from the ubiquitous Land Rover to the incredibly rare Fiat 1100 Barchetta, it's undeniable that they've left an indelible mark – and several memorable marques – on the world, which is more than can be said for the majority of the totally forgettable cars available nowadays.

My stipulation that the content featured is owned and loved for a reason still remains – seldom-used cars with no backstory or passionate owner commitment don't make the cut, however pristine their condition. Nor are the vehicles featured necessarily in concourse condition; yet as you will see, that doesn't mean they're any less worthy of inclusion. In fact they're more likely to be cherished than their private-collection counterparts. In my opinion the patina associated with use is worthy of celebrating and showing it all in its tarnished glory. As you would expect with so many possibilities ripe for inclusion, choosing which convertibles to feature was a challenge – as well as one of the project's highlights.

Regardless of era, value, rarity, style and condition, the same positive experience of owning a convertible car is enjoyed by all the featured owners. Yes, summer and convertibles go together like gin and tonic; yet such cars shouldn't just be consigned to those months (or days as we experienced this summer) when the weather is favourable. An equally rewarding experience can be gained on a crisp autumn – or even winter – day, with the roof down and the heating on high. Who hasn't yearned to own and be seen in such a car?

Over the past few months photographer Lyndon McNeil and I have had the pleasure of meeting some wonderful people with amazing cars; who've truly made the time spent producing *my cool convertible* a very enjoyable process. So to all those concerned I'd like to extend my gratitude for giving of their precious time. My hope is that you'll find the choice of convertibles featured in this book a refreshing mix. And maybe, just maybe, it will inspire some of you who are preparing to embark on owning a convertible to look beyond the commonplace choices.

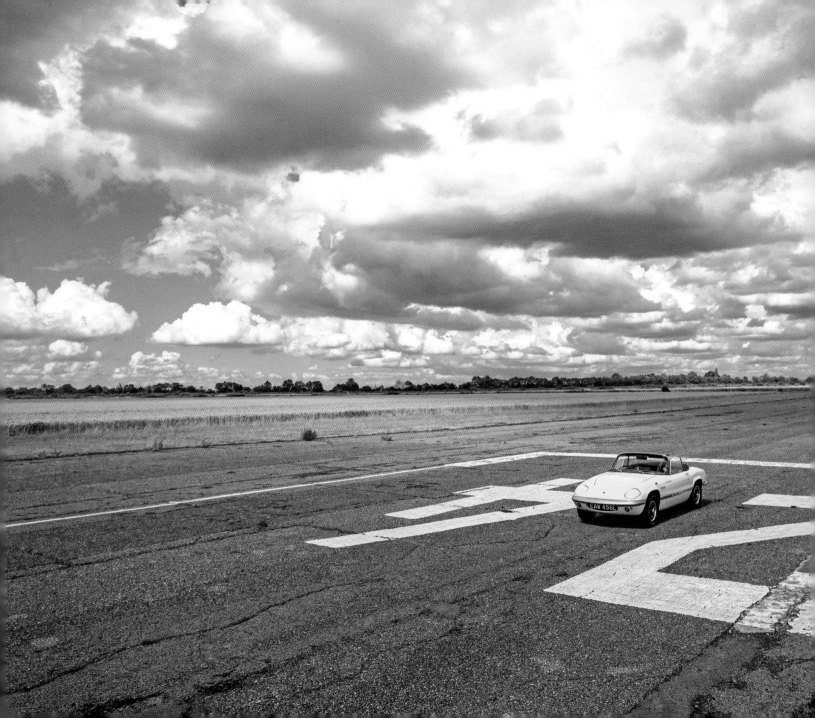

treasured

What makes a car 'treasured' for the owners shown on the following pages? One fact, which became apparent while sourcing content for the book, is that each and every one of the owners featured will have a different definition for their pride and joy, but none is less worthy than another.

Reasons often, and thankfully, go beyond sheer monetary value; for some their car is irreplaceable, bordering priceless. For a bond to be quite so strong it may contain cherished memories of a loved one, fond reminders from their youth or long-term ownerships spanning decades; recollections that become so strong that selling would be akin to turning your back on a family member.

This chapter will introduce you to the owner of a much-used heirloom handed down from father to son over several generations, each custodian leaving their imprint by way of impressive journeys, which at the same time assist in breaking down father–son boundaries. Sometimes father knows best, as perfectly illustrated by the owner of a Morris Minor. There's a restoration project with a self-imposed deadline that couldn't be missed. And, despite exterior and interior appearances, you'll find an MG that is very much loved and assigned with a vow to its previous custodians.

Some may question how the term 'treasured' can be applied to what is, after all, merely a mode of transport? It's a reasonable question, but surely unbreakable sentimental bonds can be assigned to any number of possessions for myriad reasons. It's not for us to question why; instead embrace these individuals, and for those of you who don't have similar stories maybe it will act as a catalyst for you to follow suit.

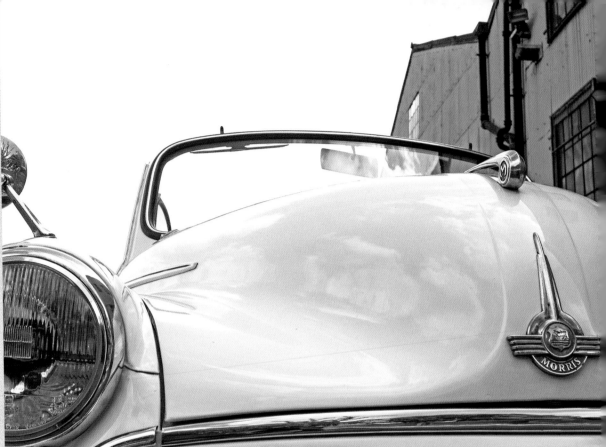

delilah

'I hadn't a clue what a Morris Minor 1000 was. So, unsurprisingly, an argument ensued when Dad took me out to view one. While I protested that I'd never be seen dead in such a motor, and that a Maestro was the ideal first car, the seller looked on awkwardly. It culminated in me bellowing, "I'm not buying it!", to which Dad tersely replied, "Tough, I've agreed a deal – hand over the money!" To cap it all there was no way I'd be driving it home, especially with a tree growing through the floorpan – this was a restoration. Dad wasn't fazed; he was a mechanic. His philosophy: what Man can build can be rebuilt – it's just a matter of time and money. Months of welding later I had a car that I'd grown to love – then five years later I'd an urge for a convertible.

'Nothing took my fancy on first inspection, while visiting a specialist who had a barn full of Morris Minors. That's until the owner cottoned on and exclaimed, "Ah, you're project people – come this way." Hidden under a sheet was a rotten shell; mechanicals and little else. He explained that the number plate alone was worth £600 – and since no one wanted it he'd effectively give us the car for free,' explains Colin, owner of this 1960 Morris Minor convertible and many, many others.

Designed by Alec Issigonis, the Morris Minor was available between 1948 and 1972, during which time 1.3 million of these deceptively roomy cars were built. Initially two models were available: a

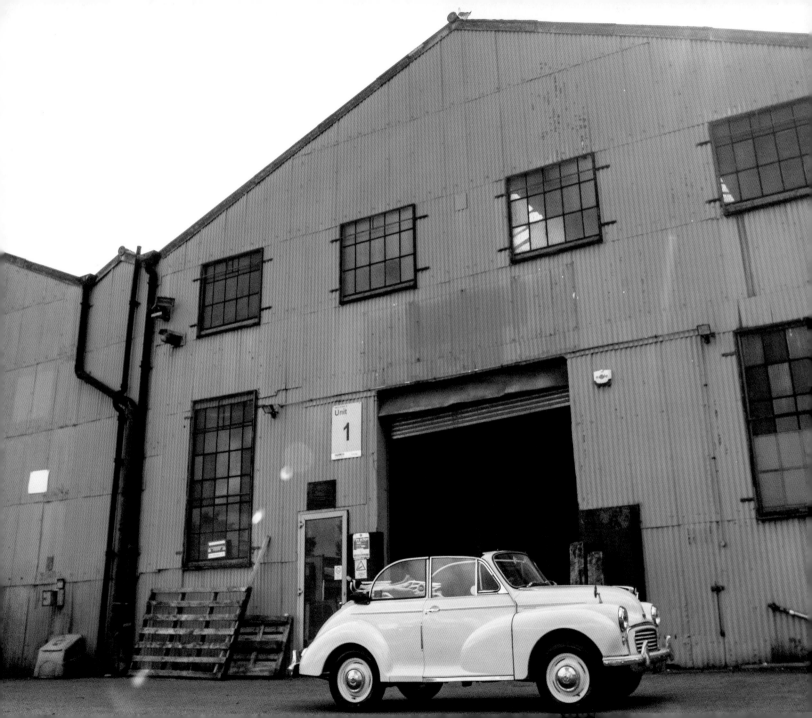

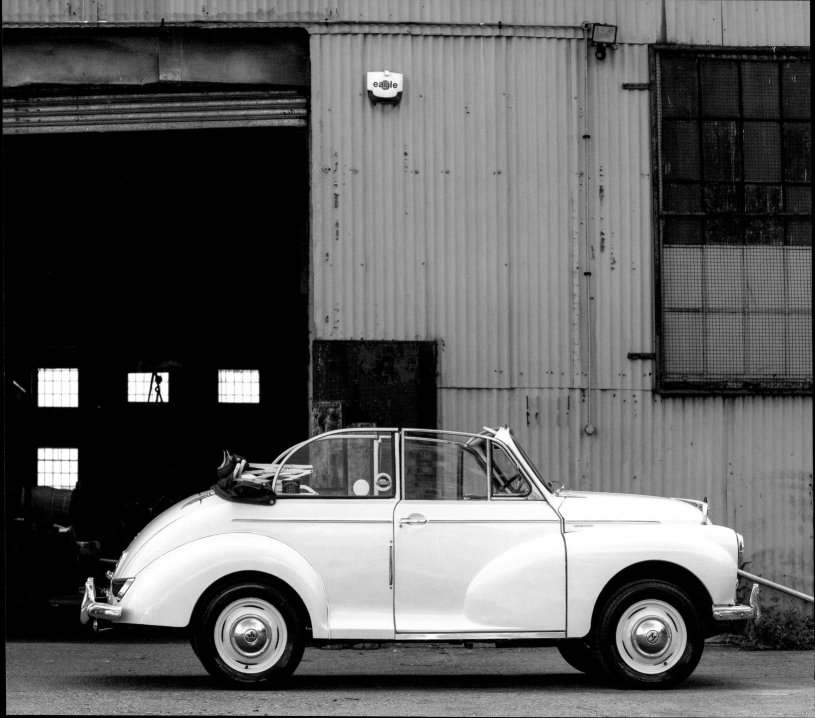

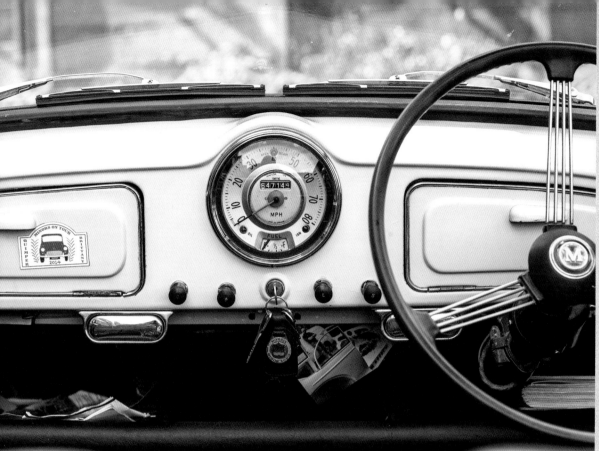

two-door saloon and a convertible – with pram-like folding roof. The Morris Minor 1000 was a 1956 update with larger engine and modified styling. Yet it retained its roots as a car within the means of the working man.

'My impatience to finish the car annoyed Dad, and likewise his methodical nature – dwelling over every task – frustrated me. Shortly after completion in 2005 we drove it on the London to Brighton run. Dad was thrilled, yet made his opinion clear that another coat of paint was needed! Tragically, just a few months later he died. Once the shock eased we slowly moved on with our lives and I carried on restoring cars in Dad's garage.

'In 2014 my car was chosen to be displayed at one of the largest (if not *the* largest) classic car shows by the Morris Minor Young Members Register. They're the same bunch who've named my car Delilah – due to that £600 number plate YOY 212 and its tenuous link to Tom Jones's "Why, why, why, Delilah". Anyhow, as a surprise and to stop the ribbing members dished out over the paint finish and non-period lights, I decided to rectify the issues in readiness for the show. Even though Delilah has an emotional attachment, it doesn't stop me using her, and I clocked 2,000 miles (3220km) on a club trip to France, for example. You were right all along, Dad; it did need that extra coat of paint – she now looks stunning.'

'By all means tag along, I told my father, but I made it clear this visit to a car auction wasn't a jolly; I was strictly there to bid on a car. As it transpired he left with a Studebaker Starlight coupé (the same model he'd owned when he and Mother courted) and I left with nothing. My wife, Caroline, is as much a petrolhead as myself – it's not uncommon for her to be trawling the internet for cars. On one occasion, knowing that I'd a growing appreciation for my father's car, she found this 1950 Studebaker Champion for sale.

'My timing was bad; in the auction's closing hours I was to be found at Beaulieu Autojumble – with no internet access! While I struggled to maintain a phone signal, atop a high wall, my brother relayed the bidding action. Thankfully I won and hastily arranged a holiday to Charlotte, USA, to collect the Studebaker. This is when the plan went pear-shaped. The car, despite what was advertised, didn't mirror it in reality; rather like a bad night on a blind date – disappointing,' comments Richard, owner of this iconic car that's a rarity in the UK.

Studebaker, a company woven into the fabric of America, was established in 1852. Initially building horse-drawn wagons, it entered the automotive business in 1902. The third-generation

studebaker

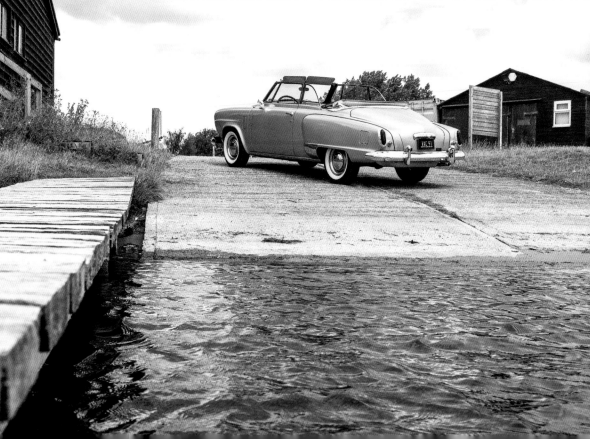

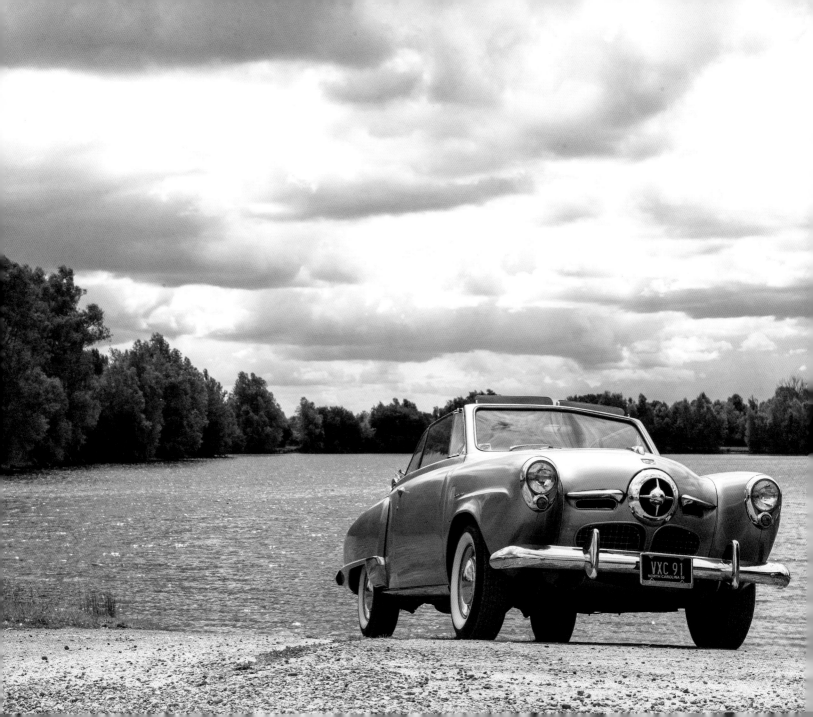

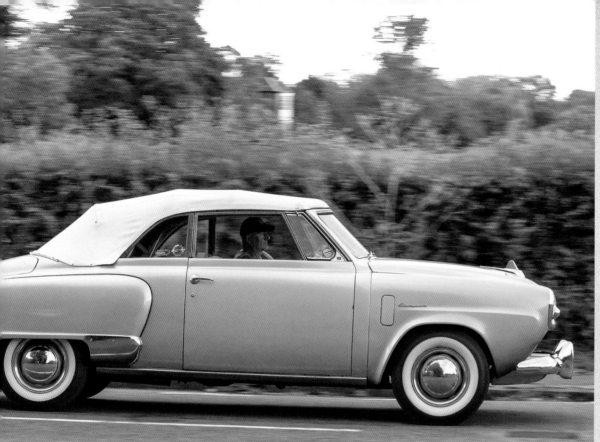

Studebaker Champion was produced between 1947 and 1952. However, the distinctive bullet-nose 'spinner' grill was short-lived and featured only for one year. The man behind this and many iconic Studebakers was French-born designer Raymond Loewy. The company had an enviable reputation for quality automobiles. Yet this didn't stop those at the top from making financial mistakes – ultimately leading to the company's demise in 1967.

'For many this setback would induce nightmares,' Richard picks up. 'However, I'm pragmatic, so I planned to deposit the car at a local workshop. Even that short distance was too dicey; so we pulled into a motel where, for several weeks, I was to be found beneath the car remedying the faults. Not a moment too soon a mechanic, who admired my choice of car, offered me free use of his workshop. Since we were in no hurry to get home – after all, I'd just turned 50 – and with the car finally roadworthy we headed to Daytona, Florida. We spent a further two months enjoying and tinkering with the car, before concluding our wonderful adventure and heading up to Georgia to ship the car home to England. When the time's right I may ship the Studebaker back to America, clock up some serious miles and then sell it on – one last fling in this superb car.'

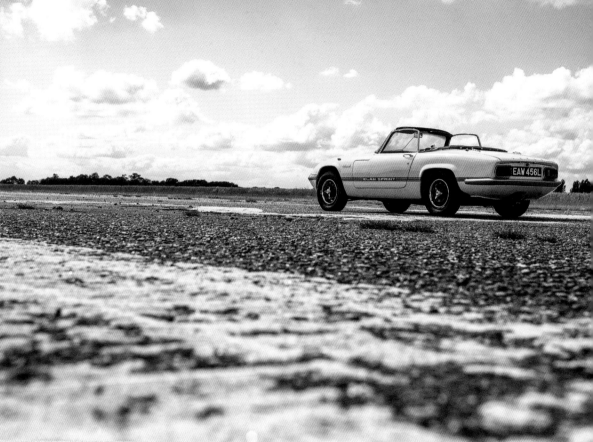

sprint

'Sporty, nippy cars have always underpinned my choice of car. At one stage I owned a Tahiti-blue MG midget – and, I'm not ashamed to say, complete with *Starsky and Hutch* white stripe. The ultimate for me, hailing from a generation that watched *The Avengers*, was the Lotus Elan. I like to think I've given the car some stability in the 32 years I've owned it. Especially as it was inexplicably passed from pillar to post previously, with eight owners in a decade. I can't rationalise why this occurred, especially as it ticks all the boxes of what a pre-eminent 1960s British sports car should be,' explains Carl, ex-physics researcher and long-term owner of this 1972 Lotus Elan Sprint.

The Sprint (1971–73) was the final incarnation of the Lotus Elan that was first introduced in 1962, the result of a collaborative team of designers – notably Ron Hickman and headed by mastermind Colin Chapman. Essentially whatever Lotus made available in showrooms was to finance the race team. Profit was everything, hence several mechanical elements borrowed and repurposed from cars such as the Triumph Spitfire. Lotus were masters at this technique

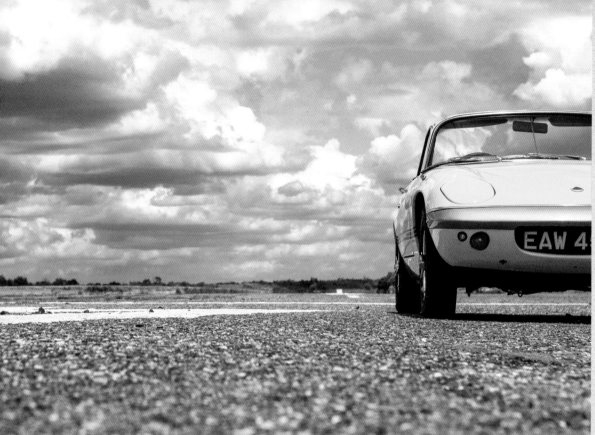

and their magic touch zeroed in on what ultimately mattered – the experience. The Sprint was essentially an upgraded Series 4, with moderately increased power by way of the lively Lotus twin-cam engine. What it lacked with its diminutive size and minimum weight design, it made up for with ingenuity and performance. Lotus implemented a weight-saving folded-steel backbone chassis (a first for a road-going Lotus) along with a fibreglass body. It became a benchmark for decades as to what a sports car should be: a popular choice for the everyday motorist, but also highly competitive on the track. It's believed that Mazda bought several Elans and reverse-engineered them while developing the MX5 – the similarities are hard to deny.

'Even I never expected to own it for this long,' concludes Carl. 'That's not to say I'm bored with it, far from it – it's testament to a car designed over half a century ago that stills feels fresh even when compared to its modern counterparts.'

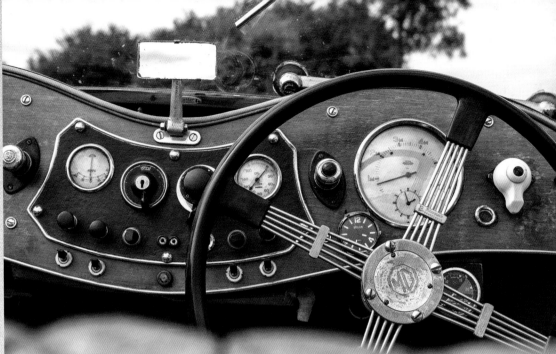

artorius

'I'd just returned from an overland trip, travelling unassisted in an Austin 7 over 38 action-packed days from China to Paris, when I noticed an advert for a 1946 MG TC Midget. The marque and model wasn't alien to me, having owned one when I was 17 – only selling it when I was posted with the RAF to the Far East. Those selling – Nick and Lindsey – were the offspring of a chap called John. They'd been charged with the sale of the car by their mother, Sheila. This was 2007; until then the car had been in the garage since John's death in the early 1970s. John was the second owner, the first being a young, but moneyed, district nurse. In 1954, when John purchased the car, he was rising through the ranks in civil engineering. In 1961 he married Sheila and the car was used on their wedding day. Two children didn't hinder the use of his beloved MG, in fact, the whole family accompanied John as he scouted locations all over England and oversaw the building of the motorway infrastructure.

'The stipulation handed to Nick and Lindsey by their mother was that the car must be sold to someone their father would have approved of. Dealers and those looking to make a quick buck were given short shrift. Eager to make a good impression, I arrived in my Austin 7 – it didn't go unnoticed. Over tea the conversation flowed and, with Sheila listening attentively to my replies, I was questioned about my intentions with the MG. Aside from a mechanical overhaul the original patina would be retained,' explains Chris, a former RAF wing commander and now, after giving the answers Sheila wanted, the proud owner of Artorius (Latin for 'Arthur'), this MG TC. True to his word the car remains in the same condition, aside from a few personal embellishments.

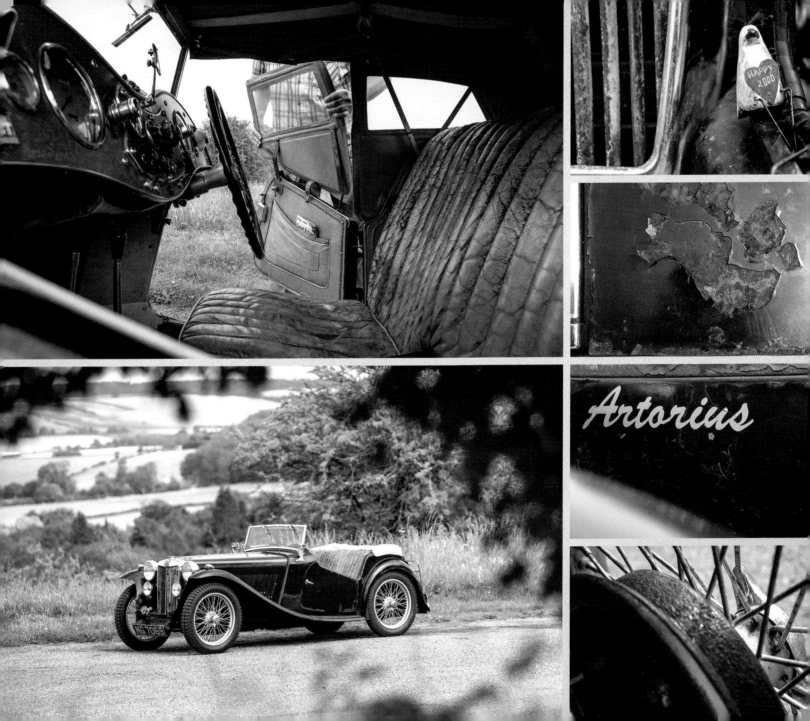

Artorius

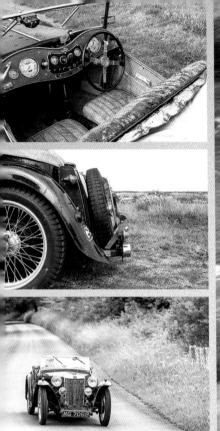

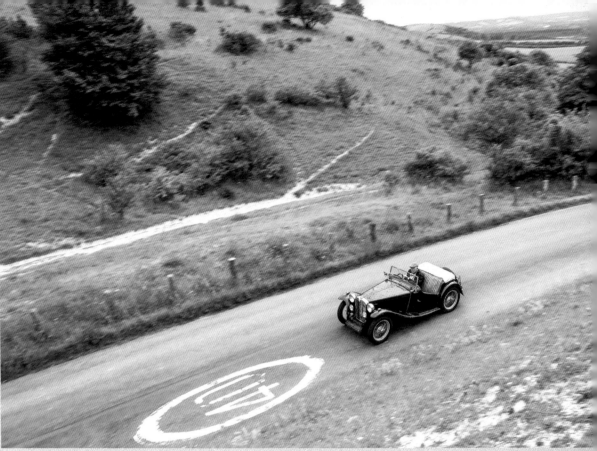

In October 1945 after being relinquished of war duties, MG announced production of the TC, only five weeks after the official end of World War Two. By the end of that year 81 MG TCs had been built – an impressive number considering the shortage of materials. The TC is a similar design to the pre-war TB and a total of 10,001 TCs were built in Abingdon between 1945 and 1949. Aside from the UK and Commonwealth countries, the USA loved the good looks of the TC; and 2,000 found their way over the pond.

'Despite flaking paint and 200,000-plus miles (321,870km), my car commands a premium for its originality. Yet it's still used extensively, rain or shine – not enough time in life to be choosy over the right kind of weather,' insists Chris. 'For an old car it handles well – I can throw it into a corner at speed and it just drifts round. My advice to others seeking a final automotive fling is get the engine and mechanicals bullet-proof and just use it! Sure, restoration is fine when you're younger – but do you really want to spend years in a garage only to be too decrepit to use it when complete?'

'It's customary for the bride to arrive fashionably late, not the groom. I was cutting it fine, securing the last bolt just minutes before I needed to leave for the ceremony. Kate's fondness for Wolseleys and love of a convertible led me to concoct the plan of presenting my newly betrothed this Hornet as a surprise wedding gift,' explains Bill, pictured with what is the holy grail of Wolseleys – a Heinz 57 competition Hornet.

'Fifty years ago, when the competition ran, you too could've been a proud owner; along with a picnic hamper, portable radio, make-up drawer and kettle, operated from the car battery, providing you with a warm beverage and a flat battery! But only if the judges deemed your picnic choice, and obligatory tiebreaker, the perfect accompaniment to a bowl of Heinz soup. With only 40 known to remain, of which 20 are overseas, I expected my quest in locating one to take me to the far corners of the world – not 300 yards away. Yet that's what happened. I'd no idea one was so close; it was after a tip-off that I wandered down the road, spoke with the seller and struck a deal. It was a rolling restoration, something I was capable of doing – however, for obvious reasons, if my furtive plan was to succeed I couldn't do it at home. Step forward Keith,

hornet soup

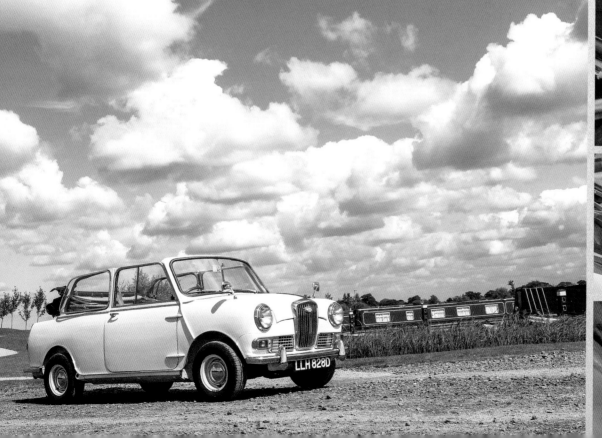

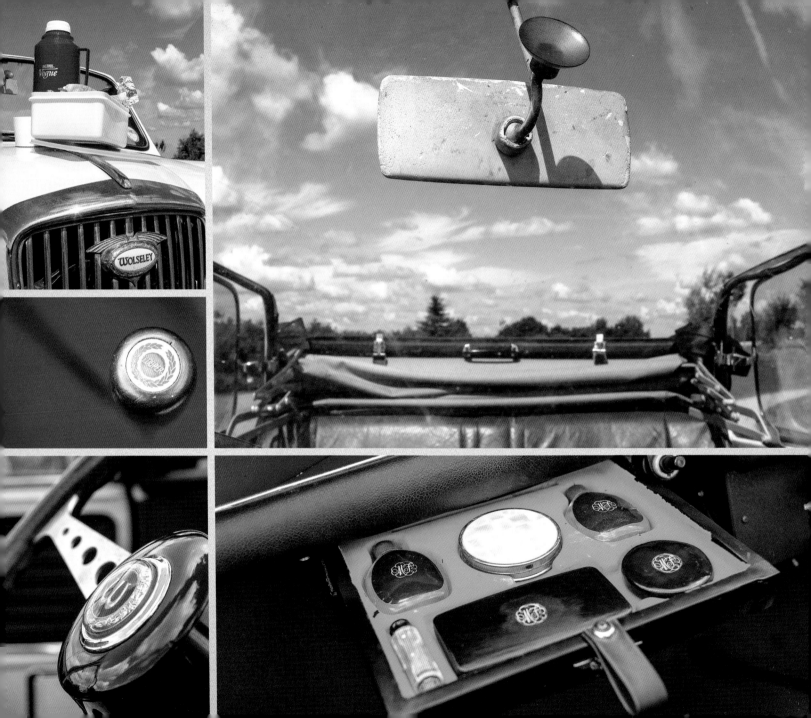

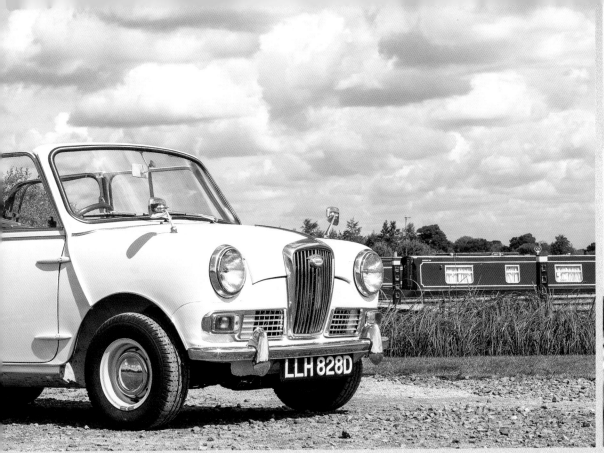

my mate from Scotland – who drove down, winched the car from my grandmother's garage (where it was hidden) and took it home. Despite six months of hard work from Keith, come wedding day, instead of putting on my fineries I was fixing bumpers, grille and lights to the car.

'With the speeches concluded and with a ruse that outside was a restoration project I'd bought as a gift, Kate and guests headed towards the exit. With a sigh of relief I opened the door and to Kate's surprise there was the Hornet – she was gobsmacked.'

Fundamentally the Wolseley Hornet was a luxury version of the Mini; tempting buyers to pay more for wood-veneer and leather. Exterior differences were an elongated boot, slightly finned rear wings and a traditional upright grille bearing the Wolseley emblem. It was introduced two years after the launch of the Austin Mini and built between 1961 and 1969.

'Kate's overriding memory of the ceremony was that I'd had oily fingers! She was displeased, wrongly assuming that Keith and I had been messing about with cars – not altogether wrong. However, it was all for Kate's benefit so she could enjoy convertible life – something the winner of this car never managed. He was 17; his parents considered him too young to own such a car, so instead made him sell it. No wonder his expression in the publicity photos is best described as "gutted"!'

happy caddy

'A promise made is a promise kept; soon my 1954 Cadillac will belong to Ollie, my eldest son. I'm not saying it's gonna be an easy transition – especially after 20 years' ownership. But slowly I'm weaning myself away from it, even though Ollie still respectfully says it will be mine. Despite owning dozens of cars, this Cadillac, imported in 1995, has been the car I turn to without fail. This year was my 20th anniversary for attending the 1,000-plus-mile (1610-km) pilgrimage to Power Big Meet in Västerås, Sweden. I'm certain I'd feel disloyal if my Cadillac wasn't among the 20,000 American cars in attendance. I can't put an exact figure on the miles I've done, due to the odometer going kaput the day I took delivery. But that is the only thing that's failed on me – I really struck gold; it's pretty much part of the family,' explains Stewart, who finds himself in this fortuitous position not through inherited wealth, just hard work. The age-old cliché of 'right place, right time' couldn't be more true.

'The allure of American cars that I'd see at the Chelsea Cruise in the mid-'70s, just a stone's throw from the council estate where I lived, led me to buy a 1959 Ford Fairlane 500. Such a car hadn't yet entered the remit of classic, so it was mine for just £60 – not bad as your first car. I left school with little career direction, plus a distinct lack of knowledge when it came to fixing cars. With both dilemmas looming large in my mind, I sought an apprenticeship in mechanics – my vocation

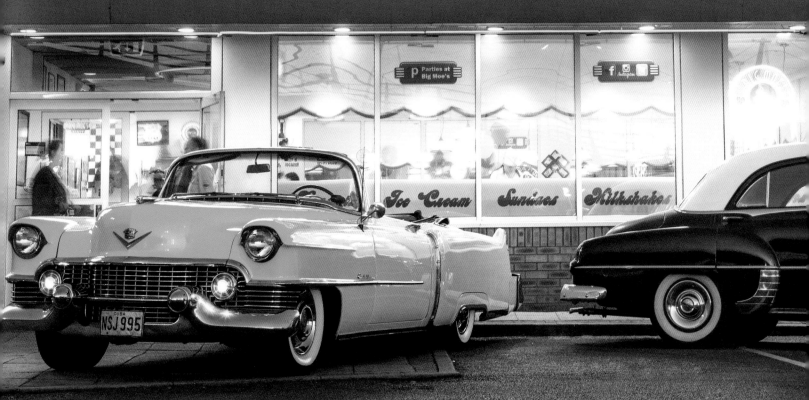

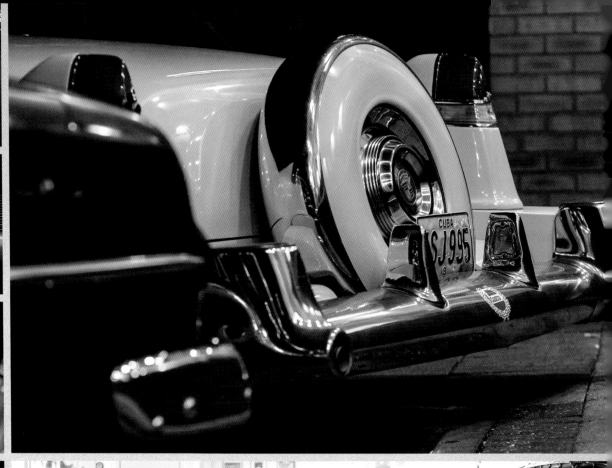

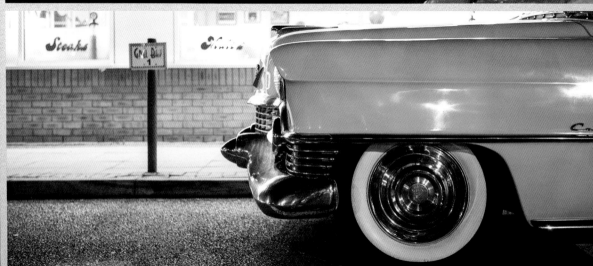

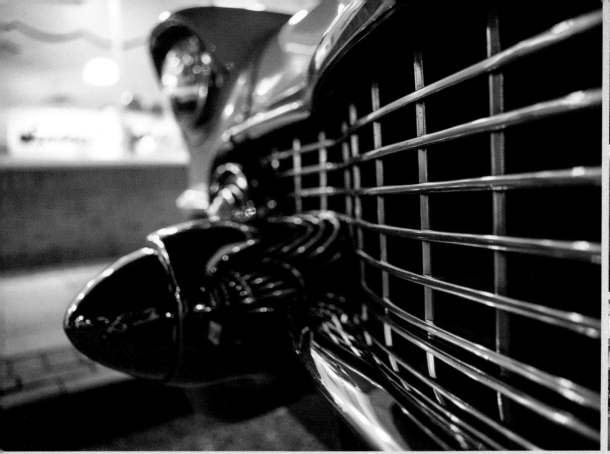

was found. Those in the motor trade often dabble in car sales – I was no exception, with my speciality being American vehicles. Around the same time as stock in the UK dried up, so began the trend of cheap transatlantic flights. Myself and my brother, having learned about the plethora of cars readily available, hotfooted it over to New York, bought three cars and shipped them back to the UK. No sooner had I advertised them than the phone rang. Thirty-plus years later, having imported close to 3,000 cars, here I am doing what I love – trading American cars and supplying similar to the film and TV industry.

The Cadillac Series 62 was yet another testament to Harley Earl, head of design and later vice president at General Motors, the same man credited as the designer of the modern car, and implementer of many of the automotive luxuries and technological advances we now take for granted. The Series 62 included a lower and sleeker (but no less gargantuan) body when compared to its predecessors, plus wraparound windshield, dagmar bumpers (slang for artillery-shaped protrusions emerging from the front bumper) and a wealth of standard features such as power steering and electric windows. It also boasted quirky attributes such as the jet-style exhaust portals in the bumper extensions and a petrol filler cap hidden behind the flip-top tail-light. No wonder sales of 134,502 units were an all-time record.

'It was the gift I knew was coming; plus there was the onus of upholding a family tradition and maintaining what's become a family heirloom. My brother and I are the third-generation custodians of my grandfather's 1934 Lagonda M45. My grandfather, Conrad Mann, was a wealthy individual, part of the Mann's brewery dynasty. Aged 24 he purchased the M45 – having, in his words, worn out his supercharged two-litre Lagonda. For two years he competed in the RAC Rally, whetting his appetite for the Monte Carlo Rally in 1936 – the must-do event for manufacturers showing their latest creations. Aged ten, Father recalls the Lagonda being brought out of hibernation; wheels put on; topped up with liquids; fuelled; and grandfather excitedly driving out of the barn for the first time since the onset of World War Two,' explains James, joint-owner of Josephine – named after his mother. Because, in James's words, 'After 81 years it deserved a name. Old cars need names – they're more than just machines.'

He continues: 'Conrad loved the car, nothing could take its place – driving it to work every day until 1972. When the keys were handed to my father, in 1988, the car had covered 337,000 miles (542,350km). Heirloom aside, it's become a catalyst in bringing the family closer.

josephine

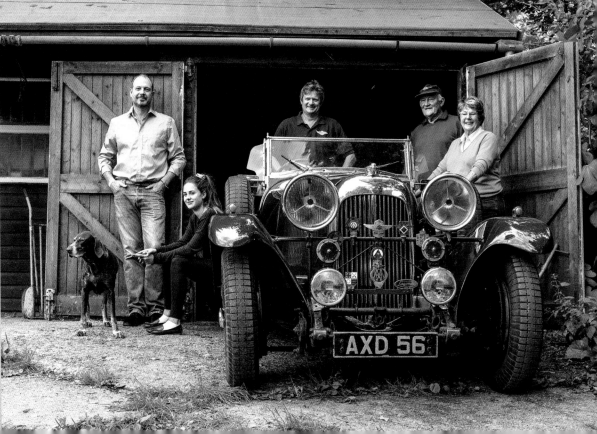

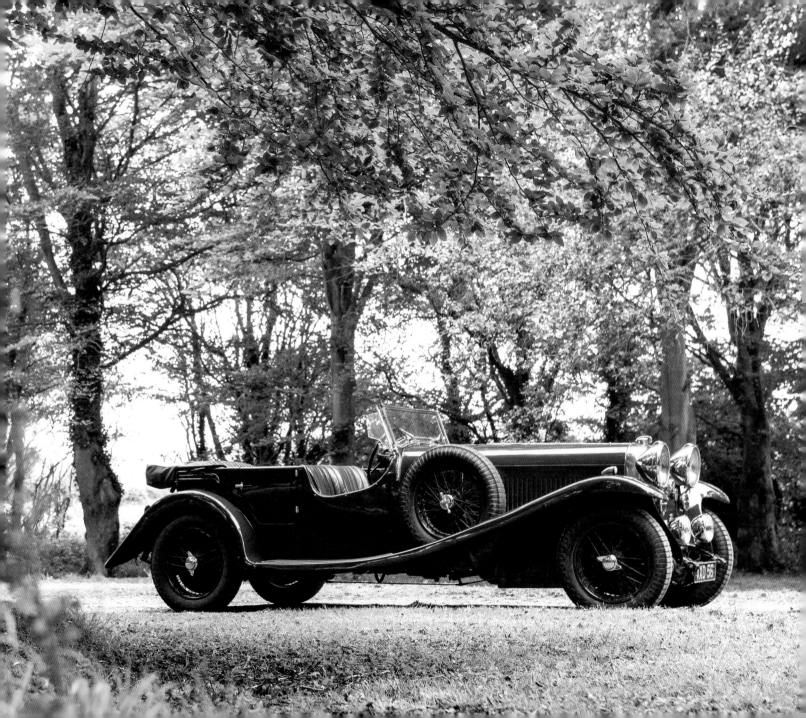

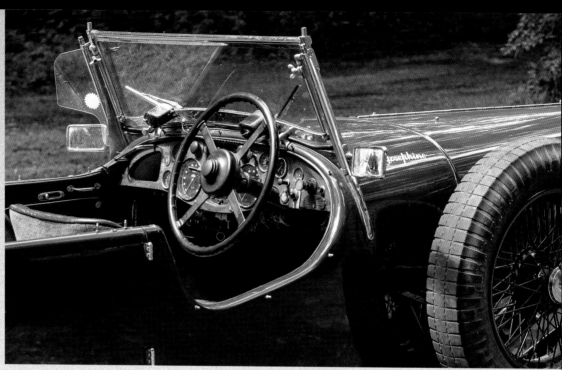

My father admits that jaunts in the Lagonda helped him bond with his father. Coincidentally, "get to know you" situations arose between my father, brother and I during the high-tension, week-long rallies we frequently take part in. When driving this car it's difficult to have any other mental processes; it absorbs 100 per cent of your concentration. Waiting; feeling and listening for that moment when you need to change gear. So any mishaps, while rallying, tend to bring out raw emotions – however, you quickly get over upsets and focus on the task in hand.'

The British luxury car marque Lagonda was established in 1906 by a Scottish-American, Wilbur Gunn. The M45 tourer, which delivered considerable performance via its straight-six Meadows 4.5L engine, is regarded as one of the most desirable prewar vintage cars. This M45 is believed to be the last remaining example of three custom builds with an elongated T5 body. Without a driver's door it promoted a more sporty entrance, while passengers still retained a level of elegance.

'I'm sure it wasn't intentional that the car be handed down from fathers to sons. Neither is there a formal ceremony bestowed upon the next in line – to be honest, it's rather informal. One day Josephine will be my daughter Katie's responsibility and, as with previous generations, I'll be casting a watchful eye over her shoulder. However, before that day my challenge is to get the car from its current 420,000 miles to half a million (675,924km to 804,672km). I'm sure grandfather is looking down with rapturous applause for us carrying on the legacy.'

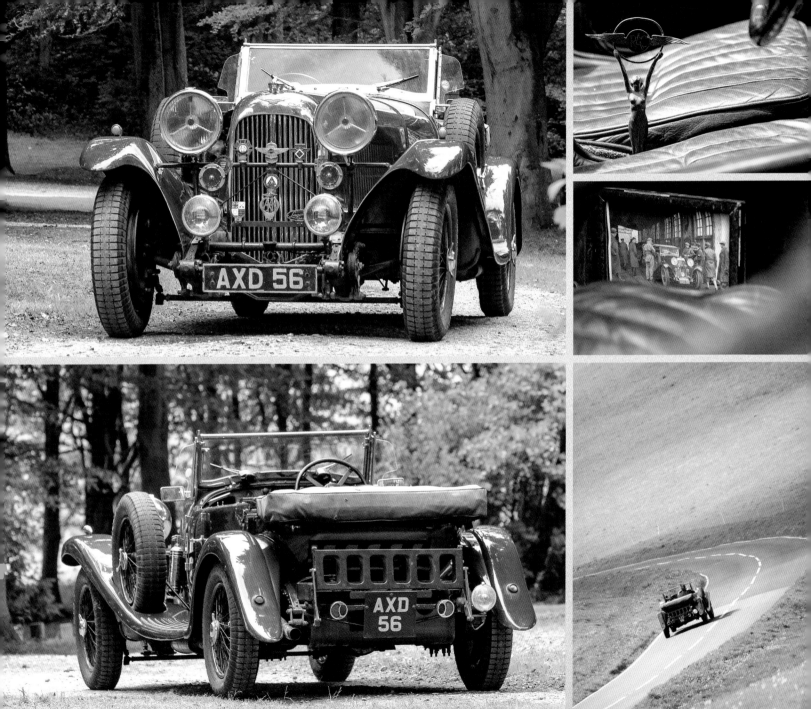

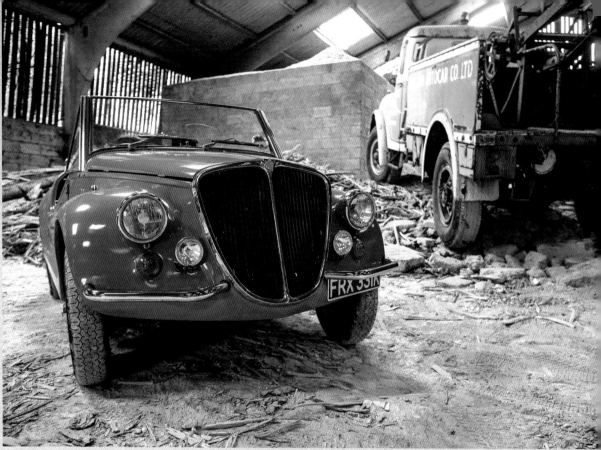

gamine vignale

'My father, who owned a garage, was approached by an elderly lady who lived in the neighbouring cottage. She explained that after her husband had died, seven years previously, the car had been gathering dust in her garage. Money changed hands, but the Vignale Gamine never made it to the garage forecourt – it was destined for me. With the aid of a recovery truck, after it promptly broke down, my mother and sister brought the car home. I may only have been 12, but that didn't stop me from learning to drive. In the years that followed, right through my teens, the little car was thrashed around the 50-acre (20-hectare) orchard my family owned – while I ebbed away at lap times,' explains Sheridan, owner of this car from a niche area of the automobile world. The Gamine's lightweight frame has caused Sheridan the odd problem, such as the day when he realised his beloved car wasn't where he'd left it: 'Though I saw the funny side of it, having eventually found the car, after mates at the pub thought it would be amusing to manhandle it to another location.'

The Gamine was the brainchild of respected Italian coachbuilder Alfredo Vignale. Having worked with the likes of Ferrari, Maserati and Lancia, Alfredo wanted a slice of the car market for himself. He proceeded to design four cars, one of which was the Gamine, an open-top two-

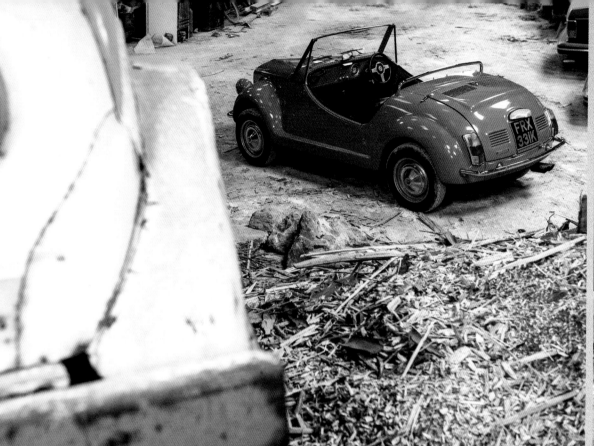

seater roadster based on a Fiat 500 footprint. Despite its fun appearance the Gamine sales were nothing to smile about. Its high price and, according to some, lacklustre performance were blamed. Eventually the ill-fated venture drove Vignale out of business, with the production facilities being sold to car manufacturer De Tomaso.

'After years of abuse the Gamine was granted a well-deserved rest. Days turned into weeks, weeks turned into months and so on. It was 2006 when I finally removed the tarp covering the Gamine and set about getting it roadworthy. Despite what it had endured it didn't need much – it never has; it's a resilient thing. By 2007 I was in convoy, with a slightly embarrassed mate driving another Gamine I'd purchased, on a 2,900-mile (4667-km) round trip to Italy. We must have been bonkers – driving through wind and rain, limping up the Alps with a broken exhaust (slashing the mighty 22hp to a whimpering 11hp) before eventually arriving in Turin.

'It's a hoot to drive and nimble – much like a go-kart. Seldom do I ever put the roof on – if it rains, it rains. It gains attention wherever I go. Case in point: a wealthy gentleman left his butler beside my car, so that on my return a cash offer could be made – a handsome sum which I respectfully refused; after 38 years, this one stays.'

'It certainly prompted much curtain-twitching that day, when the neighbour rolled up with not one but two brand-new cars. My father was doubly curious, as the origin of the cars weren't our shores or neighbouring Europe – they were Japanese Honda S800s. The curiosity eventually got too much; so nonchalantly, not wanting to appear too keen, he asked if he could take a look. My father was pro-British when it came to cars, so it was hard for him to contain his enthusiasm when he found the engineering beneath that stylish exterior was beyond anything he'd ever owned. This was the late 1960s and Honda had again proved themselves to be masters of reinvention, having only produced their first four-wheeled vehicle (the T360, a 356cc pick-up truck) a few years earlier,' explains John, whose father's interest in Hondas peaked in the 1970s when he bought an S800 roadster and then a few years later a coupé version – which by then were just cheap second-hand sports cars.

The S800, replacement to the successful S600 and Honda's attempt to produce a car with true 'sports appeal', was introduced at the 1965 Tokyo Motor Show. It was first imported into

honda s800

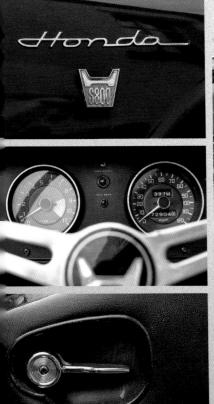

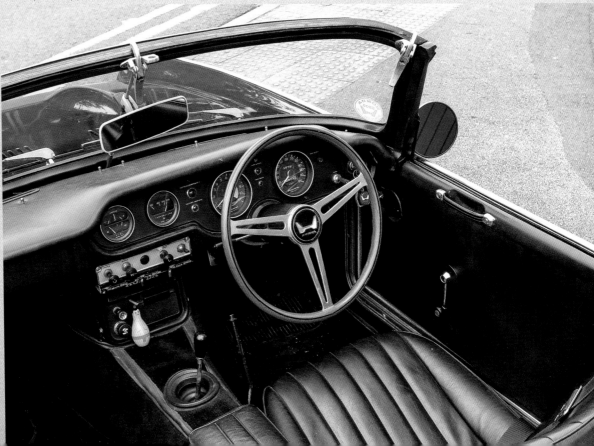

Britain in 1967; their sights were set upon competing with the MG Midget, Triumph Spitfire, Austin-Healey Sprite and Fiat 850 Spider. The 791cc straight-four engine produced 70bhp and, with a redline at 8,000rpm extending to 11,000 rpm, led to the car being described as the fastest production one-litre car in the world – Honda's first 100mph (160km/h) automobile. With the S800's small engine considered too dirty by the American market (ironic considering the gas-guzzlers of the time), it hindered sales to this all-important market. Production tailed off in 1969 and Honda chose not to manufacture another S roadster until the release of the S2000 – some 30 years later.

'Admirers often get confused and, before they clock the badge, assume it's an MG,' says John. 'Granted, outwardly there are similarities, but that's where they end. My father died in 2011 and the cars were left to myself and two brothers. Others I meet who've inherited vehicles balk at the prospect of extensively using them, instead restricting their use, unable to qualify the risk. However, my father always wanted them to be used – so we'll gladly uphold that wish.'

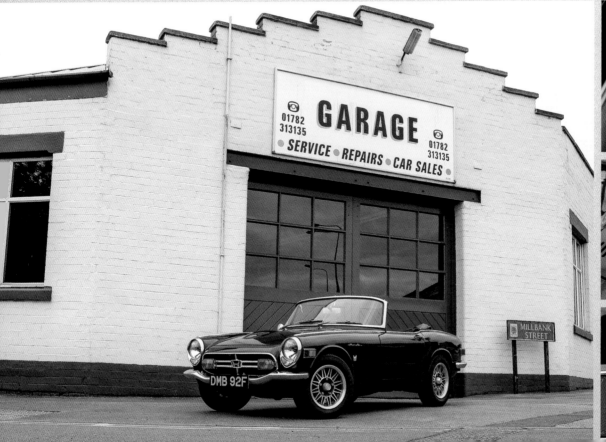

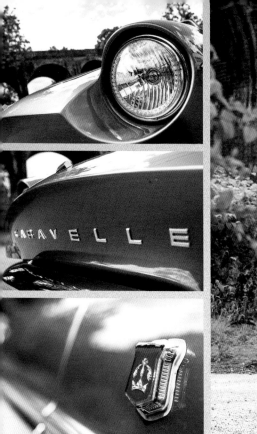

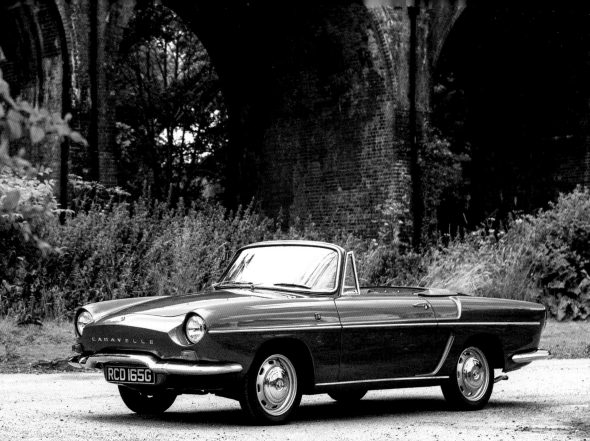

renault caravelle

'I'm more of a garage half-empty guy; always scope for more. Plus, it would've been a shame to let all that potential car space go to waste. A Renault 10, the same as my first car, made a dent in the space, but it wasn't at full capacity – a Renault Caravelle was next on my list. Since a family member had owned one, it was another car that held positive connotations for me. A classified advert I placed in the Renault Club magazine yielded a response from a farmer in deepest Essex. He explained that in a dusty outbuilding was his father's 1968 Caravelle, and it was time to let it go. He'd vivid memories of accompanying his father to the London Motor Show, where his father bought said car – one of the final three Caravelles they'd had in stock,' comments Fred, owner of this chic convertible, one of France's most iconic and much-loved cars.

The Renault Dauphine, introduced in 1956, had sold well in North America. However, the French marque was envious of West Germany's success with the Volkswagen Beetle. They wanted a bigger slice of the potential market – especially as America was starting to embrace smaller and sportier European cars. A convention of North American dealers urged Renault's chairman, Pierre Dreyfus, to build a Dauphine coupé/cabriolet as a way of boosting Renault's

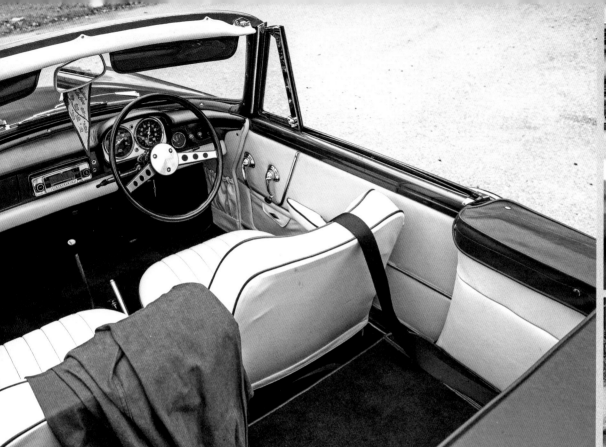

image. It was agreed and, since the gathering had taken place in the state of Florida, the car was named the Floride. However, this was considered unintentionally disrespectful to the other 49 states. Therefore the name Caravelle was eventually used for countries where the principal language was English. The bold design was the work of Pietro Frua at Carrozzeria Ghia – one of Italy's most famous automobile design houses – and the buzz was plentiful when it was unveiled at the 1958 Paris Motor Show. Production was between 1958 and 1968 with 117,000 units built.

'Until 1978, when it was unceremoniously shoved in a barn, it was well used; especially during the UK's uncharacteristic heatwave of 1976. This was close to 40 years ago; since then the car's had a much more rewarding existence – one that it rightfully deserves. With an 1108cc rear engine it's no ball of fire – but it'll happily cruise all day at 65mph (105km/h). It's a true riviera cruiser, as recognised by another icon – Brigitte Bardot. Many cars have come and gone through my garage; but the Caravelle's space isn't in jeopardy.'

exemplary

As the title of this chapter implies, it will feature, in no order of importance, vehicles that exemplify effortless and magnificent grandeur. Many are from times when individuality was paramount to vehicle design, with designers given a free hand to realise their dream. However, you'll also come across a scattering of more recent mass-produced iconic convertibles that speak volumes for the design trends of the time.

Among the mix is a racing driver who finally gave short shrift to the naysayers and realised a long-held dream. There's a coveted Bristol with a passport that even the most intrepid travellers would struggle to match. Dreams do come true and, as you will see, on occasions exceed even the wildest expectations. You'll find an Italian car collector with a stunning but diminutive duo that surpass the term 'rare', and a history-rich streamlined vehicle once owned by a pre-war daredevil. Plus the epitome of restrained elegance shown in the flowing lines of a vintage Rolls-Royce.

The preserved condition of these cars is testament to their owners' fastidious dedication. It's true that for many of us the vehicles featured will remain on our wish lists for evermore. However, while we try to console ourselves we can gaze on in admiration and imagine what it would have been like to experience driving such cars that often graced the roads of the French Riviera and other glamorous locations.

rolls-royce phantom ii continental

'I've been an owner and admirer of the marque for nearly 50 years; I started young – drawn by the allure of the name. Yet this, by far, is the most outstanding Rolls-Royce I've been fortunate enough to own. This particular Rolls I've owned for nearly five years; however, the world of coach-built cars is relatively small – often you can count a model's remaining examples on two hands – so I've been aware of its existence since the early '90s. Twenty-five years ago it was purchased and brought to Sweden from America. Then for 20 years it remained part of a private collection, accruing just 100 miles (160km) during said time. Its time spent idle resulted in a lengthy recommissioning of the engine and mechanicals,' explains David, owner of this impeccable car which, despite it being one of only two of this particular bodywork ever built, he actively uses and displays.

Conceived as 'an enthusiastic owner-driver's car', and favoured among the wealthy, the Phantom II Continental was to be the last Rolls-Royce designed under the supervision of Henry Royce, before his death in 1933. The straight-six 7.4-litre engine originated from the early 1920s and remained in use until 1932 – when the V12 was introduced. Upon placing an order

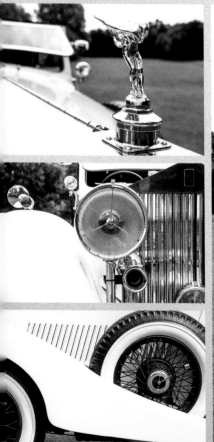

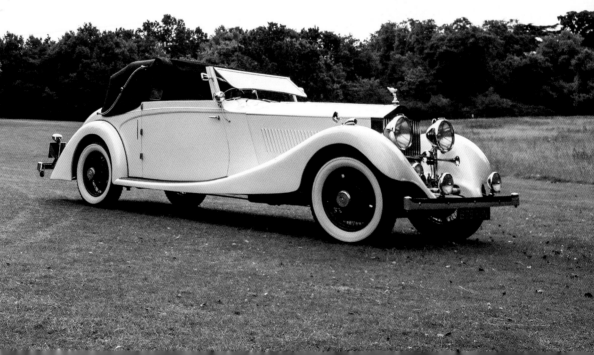

with the customer's chosen coach-builder, a rolling chassis (engine and drivetrain) would be delivered from Rolls-Royce. Skilled craftsman built a wooden (ash) framework, before beginning the process of folding, hammering and honing the metal panels around the frame, leaving the car trimmers to embellish the interior with the customer's choice of materials. The sedanca three-position roof enabled it to be open, closed or partially closed – leaving the rear passengers covered. The finished car embodied the grace and sophistication associated with refined luxury motoring.

'A notable outcome of my Rolls being driven, not hidden, was correspondence from a gentleman who'd observed my car and had a suspicion that it once belonged to his father. Details were bona fide and it was indeed his father who in 1931 commissioned the car to be built by Ranalah Limited, London. We arranged to meet and, over afternoon tea, stories of his father's time with the car were recounted. The car was actively used until his father's death in 1950, at which point the car was sold and shipped to America. A tangible connection with the original owner was the icing on the cake.'

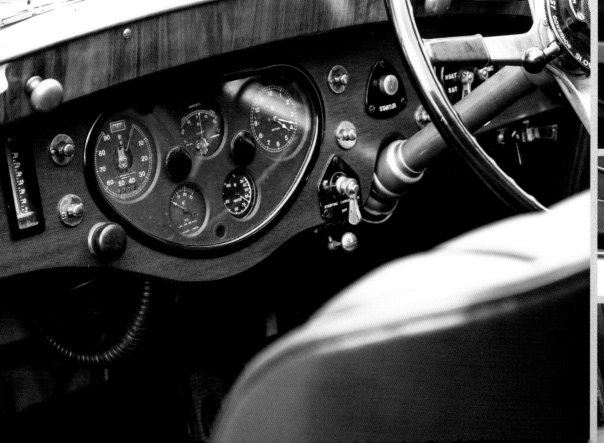

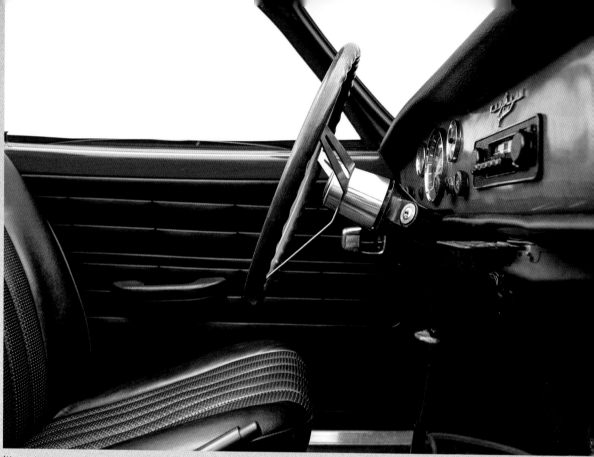

karmann ghia

'I've always adored the shape and ethos of Volkswagen's Karmann Ghia; even as a child I remember thinking just how weirdly wonderful they looked. The bodyshell alone, that even nowadays would scupper many manufacturers, was so futuristic – there was nothing to match it! I decided 2012 was as good a time as any to fulfil my dream of owning one,' says Martin. 'On hand was another Martin – good friend and the UK guru of Karmann Ghias, Martin McGarry. His assistance was imperative to avoid my dream turning into a rusty nightmare.

'I didn't have to wait for long; up for sale was a 1968 Karmann Ghia I'd prior knowledge of – having seen it on the programme *Wheeler Dealers*. Martin had been an advisor to the show, so out of duty they offered him the car at a thoroughly reasonable price,' explains our Martin, owner of this car sourced by TV's Mike Brewer for the hit TV series. 'The show's pretext was that Mike would scour the classifieds, locate a classic car (which in this instance belonged to a family in Idaho, North America, who were selling it to fund a family member's university education) and ship it to the UK – so grease junkie Edd China could work his magic and hopefully return a profit.'

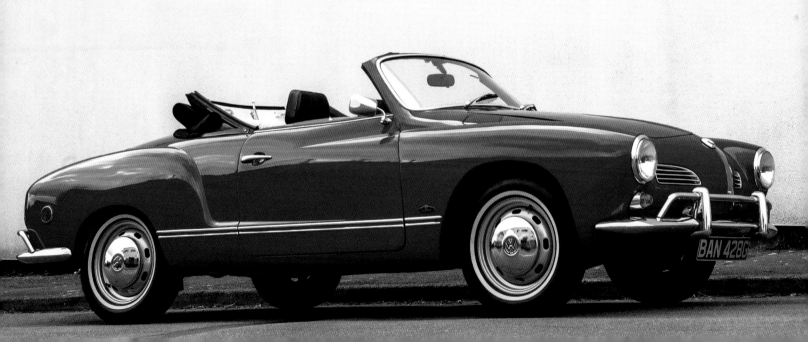

The Volkswagen Karmann Ghia is regarded as a classic of automotive design. It was the desire of Wilhelm Karmann (owner of Germany's largest independent vehicle manufacturer) to create a sports car based on the humble, yet reliable, VW Beetle. He, along with design house Ghia, developed a prototype (without Volkswagen's knowledge) and presented it to VW; it was greeted with total admiration. It may not be the fastest car in the world, but its coach-built lines promote nothing but motion. A total of 445,238 Karmann Ghias were built, of which 80,837 were cabriolets, between 1955 and 1974.

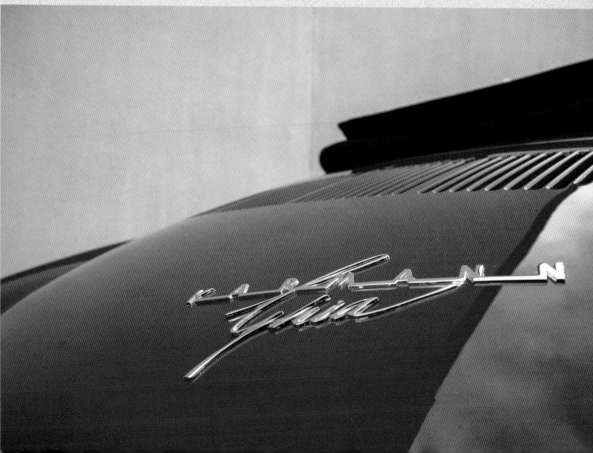

'Obviously there are limitations to what can be achieved and shown within the confines of a one-hour show. So recently, while re-trimming the interior, I discovered a quarter, an uncomfortably large dead cockroach and an old poker chip – linking in nicely with the first owner, a Texan doctor who's believed to have had a gambling issue. I don't bang on about the car's TV provenance; however, with the programme repeated with the regularity of night following day, it's getting more widely known – but this won't stop me from using this glorious car.'

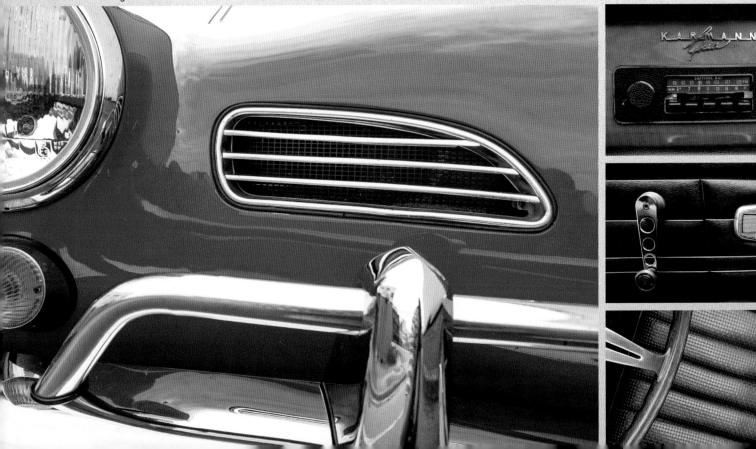

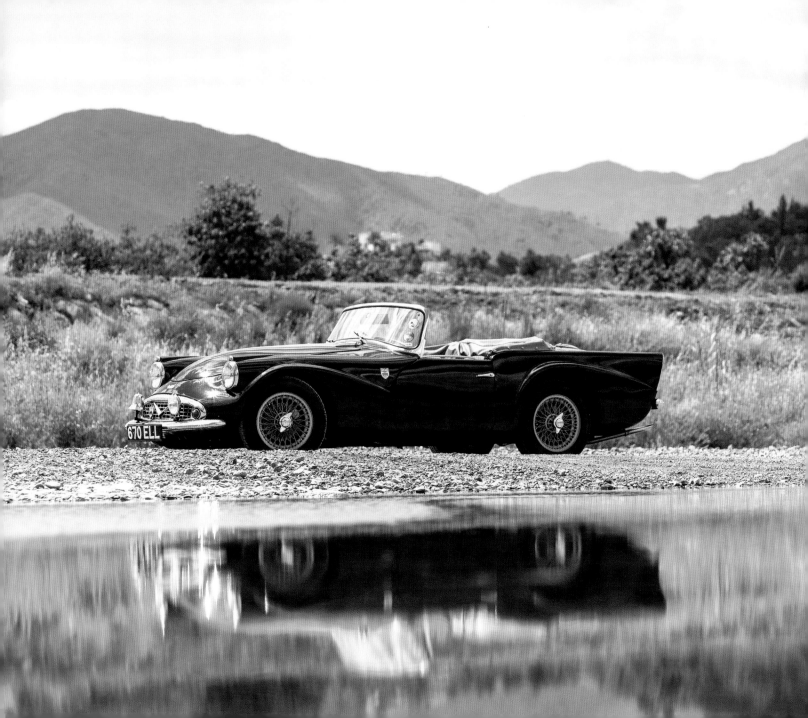

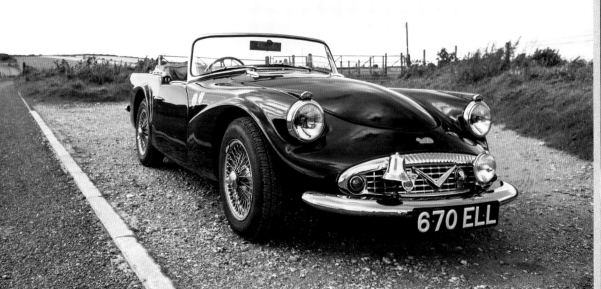

'As techniques go, practising your cornering around prehistoric monuments in an Austin-Healey is fairly obscure. But in the 1960s access to Stonehenge was just a gate-latch away and skirting around unforgiving 25-ton stones certainly hones your skills – giving me the edge when it came to my career in motorsport. My post-school career was expected to be that of farming; after all, it was my father's profession and I'd been helping on the farm since I was a nipper. However, my temperamental motorcycle, which I bought aged 16, resulted in many trips to a local garage. So frequent in fact that Mr Ayers, the owner, would let me serve myself and sling the money in the till. One day he asked whether I'd like to become a mechanic and offered me an apprenticeship. I was hesitant; I didn't want to leave my father in the lurch. But, unbeknown to me, he'd already cleared it with my father and the job was mine, with his blessing, if I so wished,' explains Win Percy, not only the owner of this Daimler Dart but multiple British Touring Car Champion, historic car racer and conqueror of the 1990 Bathurst 1000 – the pinnacle of Australian motorsport.

'My love of driving and mechanics evolved into motorsport – Autocross, to be precise. After a successful spell I grew tired of the sport's destructive element. So I bought myself a Datsun 240Z and

win percy

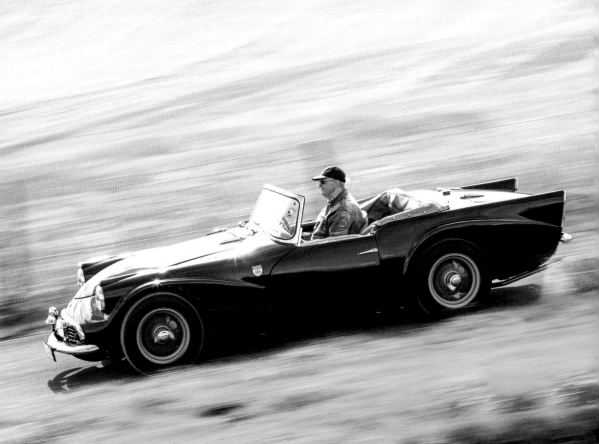

sought the services of Spike Anderson, who enhanced the car and then appointed me as Samuri team driver after I won the Gurston Down hillclimb. My career blossomed and, despite being like a fish out of water, I rose through various cars and classes. In 1975 I was racing in the touring car series and won my first race. A guy who I'd been tussling with on the track approached me and said, "First race? You're good – one day I'll have my own team and I want you to drive for me." We shook hands and off he went. At that time I'd no idea it was the renowned Tom Walkinshaw. In 1979, true to his word, he signed me to drive in the 1980 season – I won the championship and my career propelled henceforth.

'For decades I've been an admirer of the Daimler Dart. I'd have owned one years ago, if not for friends referring to it as "bloody ugly" whenever I mentioned that I wanted one. Four years ago it was time to get my hands on the ex-police Dart that'd been seen during events at Goodwood. Despite it going to auction I tried to bypass the bidding and buy it direct from the owner. However, after consideration I opted to risk it and bid at auction – especially as the Dart market wasn't too buoyant. I ended up paying well over the odds – but I couldn't resist it.'

The Daimler SP250 Dart was the last car built by Daimler (1959) before the company was sold to Jaguar in 1960. With a 2.5-litre V8 engine and fibreglass body, it was quick and agile. Thirty Darts

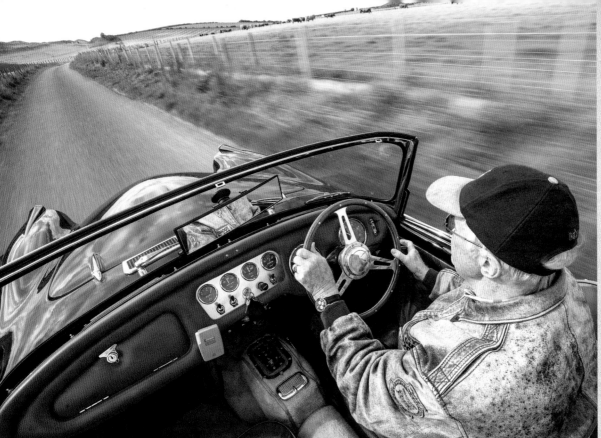

were commissioned and modified for police duties, in order to keep up with and bring under control the 'ton-up boys' who'd race their motorcycles on the streets of London. Sadly, to avoid any internal competition with the Jaguar E-Type the Dart was dropped in 1964.

'Being a racing driver isn't about bravery. Nonetheless, my grit was tested when my tyre exploded at over 220mph (354km/h) during Le Mans in 1987. I ricocheted off the Armco, looped repeatedly and landed a third of a mile (0.5km) later, with nothing of the car remaining aside from the tub around me – I emerged without a scratch. So you'd expect that when my career was brought to an abrupt end in 2003, it would be the result of motorsport? Instead a surgical blunder, after sustaining an injury while gardening, left me paralysed from the waist down. However, not much stops me, even the prognosis that I'd be confined to a wheelchair for life.' It certainly doesn't – after much hard work and determination, Win can now get around on sticks and drives his Dart via hand controls.

He concludes, 'Motorsports has given me resilience; a will to never give up and instead focus on a wonderful life, wife and fortunate race career.'

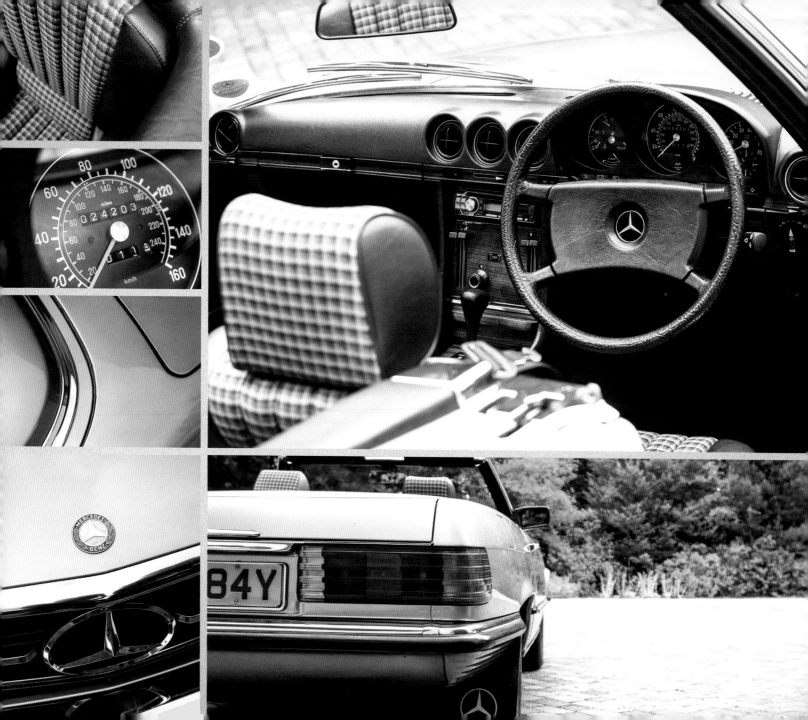

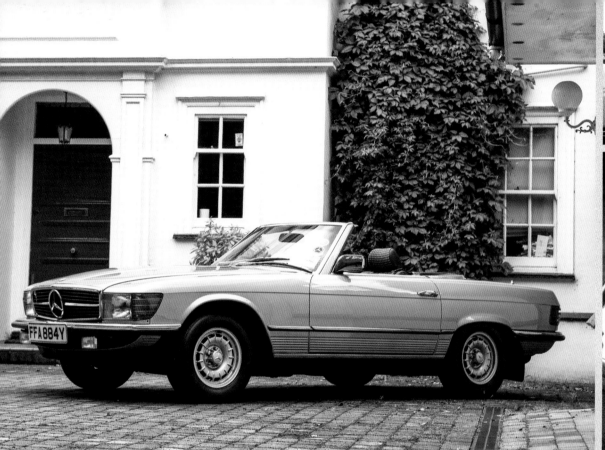

'I'd like to think I know a fine product when I see one,' explains Samuel, a facilitator in sourcing luxury items, including cars, for high-level individuals who look to invest sizeable sums in assets they can enjoy. 'I deal with classic car collectors on a daily basis, so I'm well versed in what the latest appreciating classics are or may become. An emerging classic, but no less rewarding, is my 1983 Mercedes-Benz 380SL – it looks resplendent in gold with complementing brown hood. It's a slowly appreciating classic that's currently in the shadow of its predecessor – the Pagoda. While this continues it will remain a stylish, desirable, robust yet affordable classic.

'I learned about this sublime SL 12 years ago; it was an absolute gem and I tucked it away at the back of my mind. The owner was a friend's grandfather (an ex-PGA golfer) who'd cosseted the SL for decades and it had only accumulated 24,000 miles (38,624km). At that time it wasn't even for sale; it seemed destined to remain a pipe-dream. However, three years ago when it

mercedes-benz 380sl

finally came up for sale I wasted no time in arranging a meeting. A figure from the *Mercedes Owners Club Magazine* was pointed to: "I'll go to the bank now," was my retort. There are times when you negotiate – this wasn't one.'

The Mercedes-Benz R107 and C107 SL (Sport Lightweight) series defined personal luxury cars for almost two decades, becoming the second-longest production run in Mercedes history – proof that real class never goes out of style. More than 237,000 roadsters were built between 1971 and 1989.

'It's unbelievable just how well the car still drives. Thus, I'm presented with a double-edged sword – use it or try to keep that mileage low? I'm always keeping a watchful eye open for other classics I could acquire, in order to build a modest collection. At the forefront of which will be the SL – because, aside from the fact it shares my birth year, this is the car where it all started.'

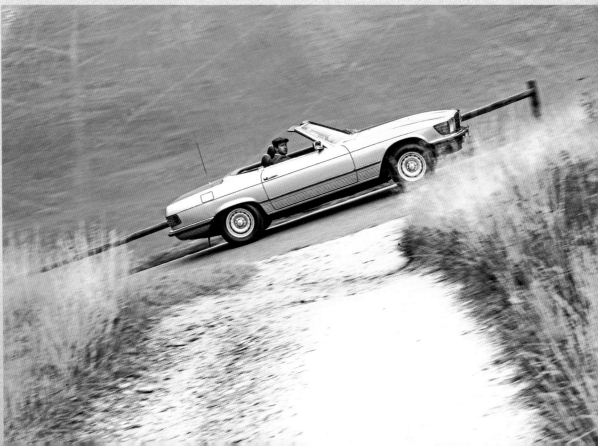

alfa romeo

'The actions, on a blisteringly hot day in Italy, of a suave gentleman pulling up outside a restaurant in his Alfa Romeo 2600 Spider is a memory that's stuck with me. It was the sureness of his actions, that no one would dare ask the owner of such a car to move on, that resonated. While at college I was fortunate enough to own an Alfa Romeo Bertone GTV. However, it was only eight years ago that I realised the dream and acquired this 1964 2600 Spider, which had been part of a private collection for 20 years. It was also approaching an era that would be a turning point for the 2600. Prior to this many had been left to rot away – pretty much unloved and unappreciated,' explains Ian, owner of this now appreciating Italian classic.

The designers responsible for penning the 2600 were Carlo 'Cici' Anderloni and Federico Formenti of Italian automobile coachbuilder Carrozzeria Touring. Aside from the beauty of their designs they patented the Superleggera (super-light) construction method. The 2600 Spider (the name deriving from two-seat horse-carts with a folding sunshade) lacks the nimble handling attributed to the marque, particularly when compared with other Alfa models.

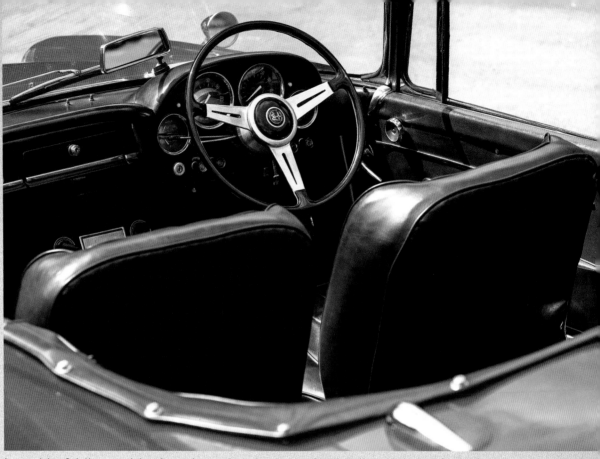

Instead its 2.6-litre straight-six engine and opulently appointed styling, both exterior and interior, qualify it as more of a grand tourer. It was to be Alfa's answer to the Jaguar E-Type, yet its price was a prohibitive factor and it achieved only limited success. Approximately 2,300 were made between 1961 and 1968.

'I'm just an ordinary chap, who was fortunate enough to have the luck and foresight to buy one of these stunning cars when prices were low,' concludes Ian. 'Some owners now more often have a wealth of cars; their Alfa Romeo 2600 just one of many. Like many classics, the 2600 is heading in the direction of being solely in the hands of collectors, who, unlike myself, will seldom drive it – which in my opinion is a tragic shame.'

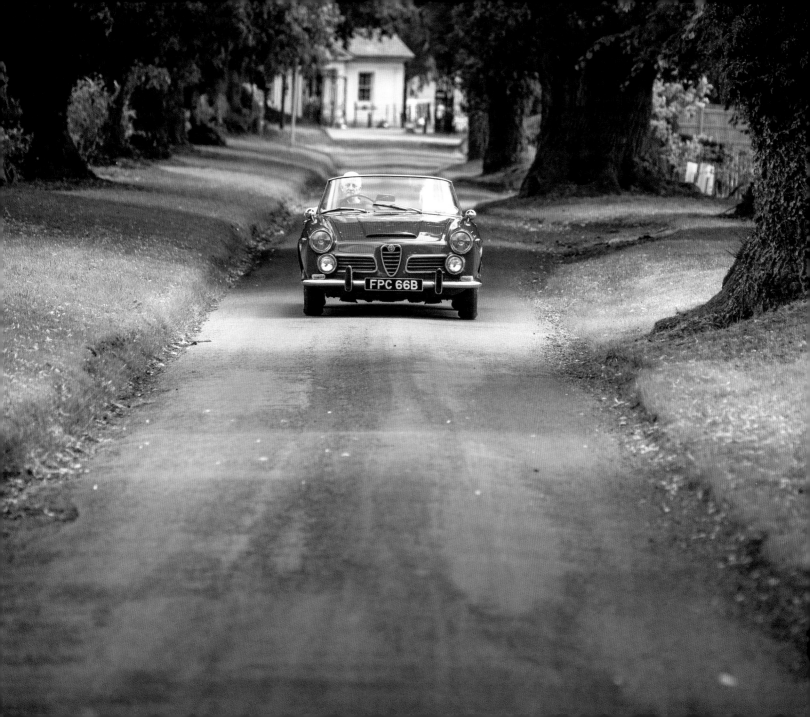

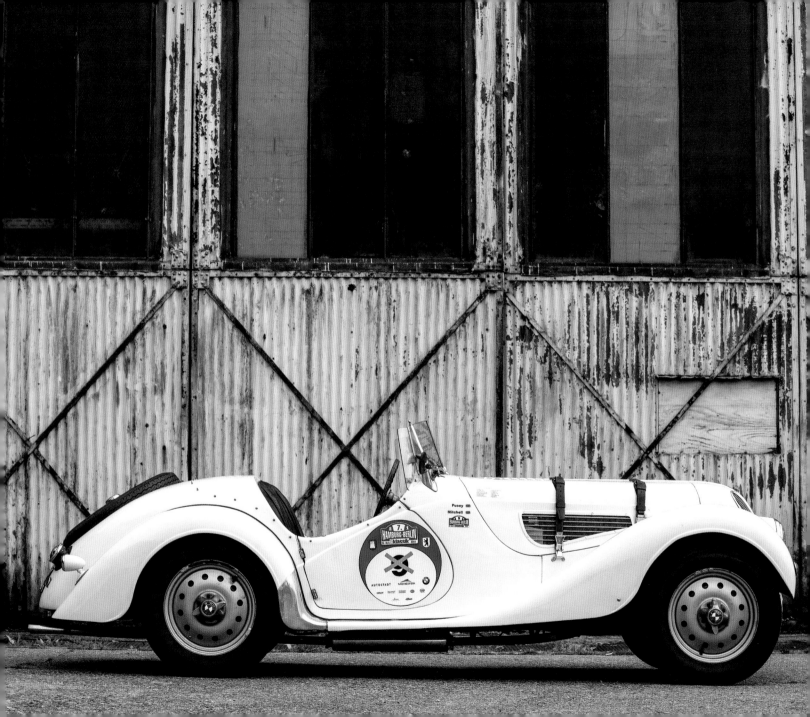

'Sadly my father never had the chance to see the cars I've collected. It's especially poignant considering it was he who introduced me to the world of prestige cars. He worked most of his life as a chauffeur, mainly for wealthy individuals, making our home in London's suburbia an overnight parking spot for a variety of exclusive vehicles: Rolls-Royce, Bentley and Aston Martin. His enthusiasm and knowledge of vehicle mechanics was extensive – it had to be. Waiting for roadside assistance with a VIP in transit wasn't the done thing. My first serious car, one I'd admired from an early age, was a Bristol 411, which in turn led me to a Bristol 404. Once you've an appreciation for two-litre Bristol engines you soon make the connection with pre-war BMWs – such as my coveted Frazer Nash-BMW 328,' explains Gary, owner of this history-rich car.

In 1936 the streamlined car was ground-breaking – when it entered a race it inevitably won. Behind the wheel was Hugh Curling Hunter, a man of independent means and active gentleman racer. Initially he competed and won in cars from British sports car manufacturer AFN, founded by Archibald Frazer-Nash. At least, he did until 1935, when BMW stole the glory.

frazer nash-bmw 328

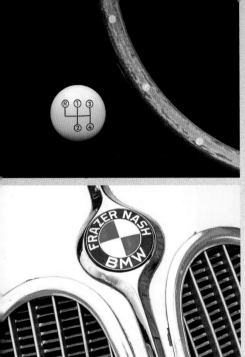

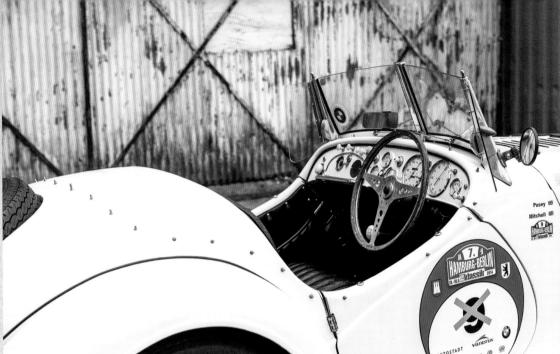

AFN were impressed and requested that BMW award them a licence to sell their cars in Britain; Frazer Nash-BMW was born. When the 328 was launched, a car as happy touring as racing, Hunter placed his order. A total of 462 were built, of which 46 were badged as Frazer Nash-BMW. On delivery day in 1937, Hunter immediately drove to Brooklands and tested the car on the banked circuit. In the years before World War Two he competed extensively in the 328, racking up many wins. After he sold the car it resurfaced and won at the inaugural Goodwood meeting in 1948 in the hands of Ken Watkins.

'As cars often do, the 328 faded into relative obscurity,' recalls Gary, 'until the '70s, when it became part of a private collection. In 1980 it was sold at auction and spent ten years in a museum in Perth, Australia, before being acquired by a collector in Canada. In 2001 I was heading to Vancouver, having responded to an advert for the 328. My appreciation for the car was enough for the owner to agree to my below-advertised offer. Fortuitously that year's cherry harvest was late, delaying export, which meant there was a fruitless 747 heading to Heathrow with cargo capacity going cheap. My 328 travelled back in style.

'It took two years to restore the car mechanically, during which time I amused myself by joining up the dots as to the car's history – race photographs, original purchase order, manuals and handwritten lap times from Brooklands. Knowing what I now know about the car brings it fully to life.'

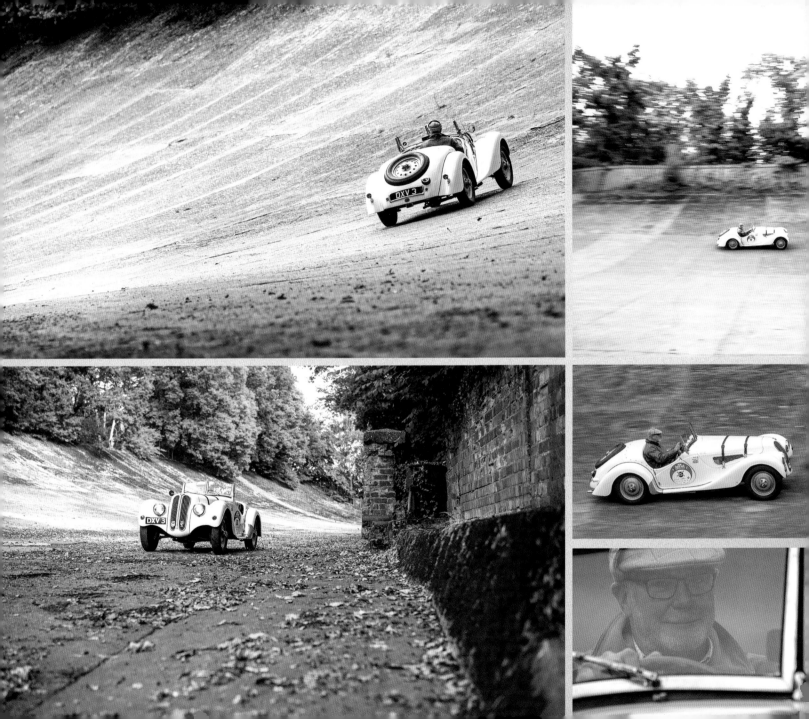

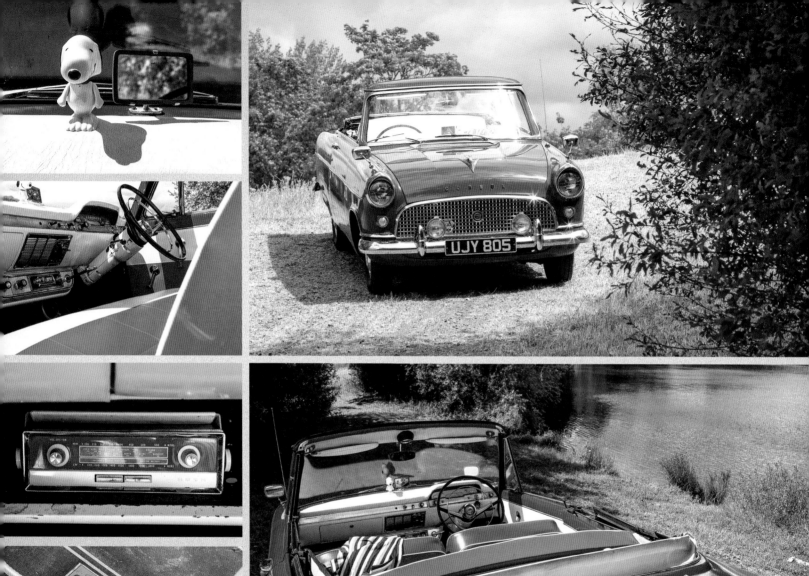
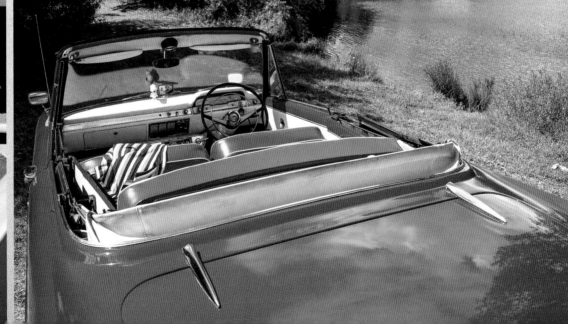

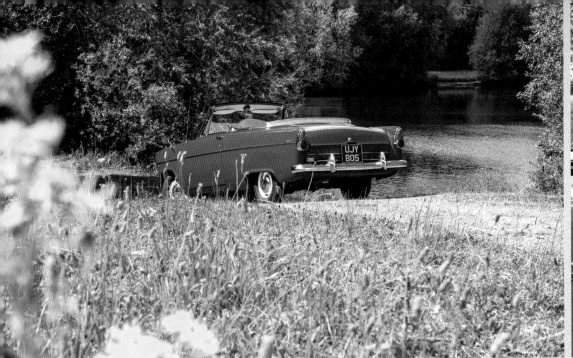

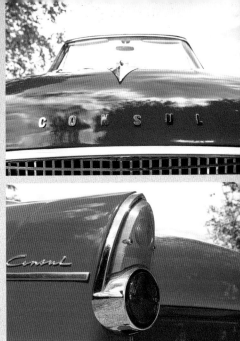

ford consul

'I do like Fords: pleasant to drive, easy to fix – perfect for the avid mechanic to dabble with. I acquired my first, shortly after passing my test, back in 1964 – a Ford Zephyr Mk2. Initially my dad wouldn't let me drive it, considering it way too powerful for a lad of my motoring inexperience. Imagine that! Having a car you couldn't use was tantamount to torture. However, a by-product of those weeks before he finally relented was that it did get remarkably shiny. Thankfully I proved him wrong by clocking up many years of responsible driving. This 1961 Ford Consul Mk2, purchased in 2008, was to be my first convertible; something I'd wanted for a very long time,' comments Reg, owner of this encapsulation of American automobile styling for the British roads; all the glamour at a fraction of the size.

'In the instant the words "Fancy a holiday in Scotland?" fluttered from my mouth Jan, my wife, knew a car was the source fuelling my offer. Luckily she'd wanted to visit Scotland for a while; so no need for too much arm-twisting. Eight hours by train to Scotland, five days to drive home – not through mechanical or Jan's map-reading issues. I know, I know...I'm kidding. Instead a very pleasurable meandering route home via the highlights of the Highlands – roof down, of course. What better way to familiarise yourself with a car?'

With styling cues inherited from American cars, such as the 1950s Ford Fairlane, the Consul Mk2 was built between 1956 and 1962. The stainless-steel brightwork and vivid contrasting interior and exterior colour schemes helped inject some much-needed glamour into UK motoring. The Consul, despite sharing the same bodyshell, was still the sub-model of the Zephyr range, sporting a four-cylinder engine as opposed to six-cylinder. Some 9,398 all-steel saloon Consuls entered the Coventry factory of Carbodies (manufacturers of London's black taxicabs) and left as convertibles.

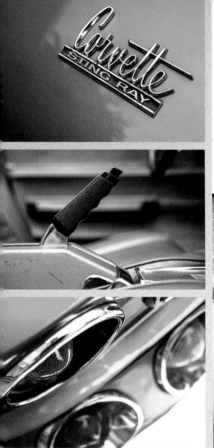

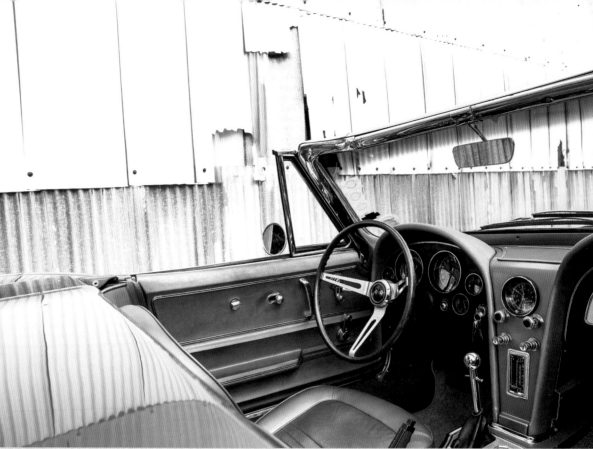

corvette

'Despite my partner, Laraine, buying me a new car stereo, I've yet to use it. Reason being I've the euphonious chant of a V8 engine a few tantalising inches ahead of my right foot – which, let's face it, trumps anything that the speakers could emit. It's such a distinct tone – a near-perfect definition of heaven. I'm not exactly sure what marque of car defines that of an accountant; however, I guess my choice does transcend the norm. For me it's the perfect antidote to fiscal year-end spreadsheets,' explains Dieter, who has cherished this 1966 Corvette C2 Sting Ray for the past 13 years.

'Life's too short to avoid doing or owning the things you want – I've lost too many friends over the years. Plus, it's currently a better investment than anything else I've ploughed money into and a damn sight more fun. It took four years of searching to find this car. I discounted many and held out for what I really wanted: a marina-blue (not stereotypical red), 350bhp, 327-cubic-inch, small-block V8 with four-speed auto transmission.'

The coveted second-generation C2 Chevrolet Corvette (also known as Sting Ray) was produced between 1963 and 1967. The Corvette remains the longest-running sports car

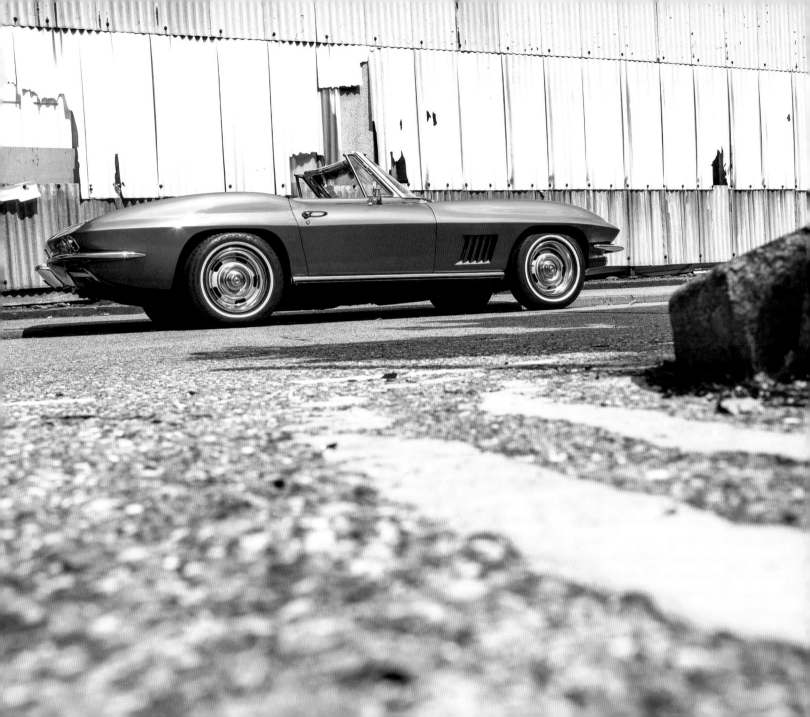

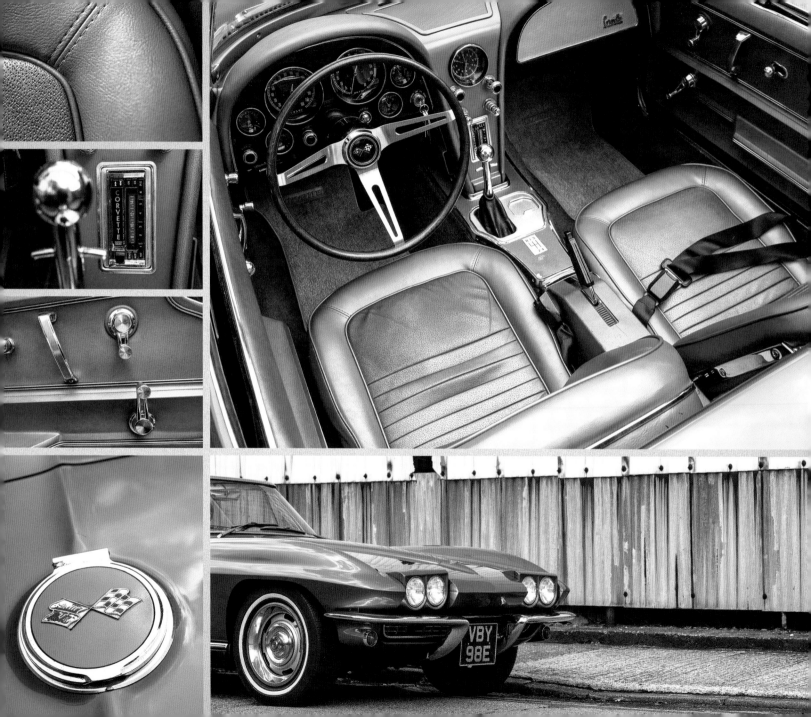

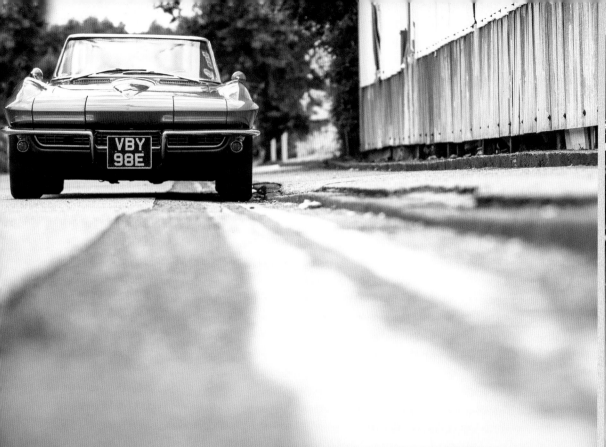

brand in the world, with continuous sales since 1953. This was to be a new generation for the Corvette, blending world-class handling with unmistakeable all-American style and performance. The curvaceous fibreglass bodywork (reputedly inspired by the Jaguar E-Type and the sleek shortfin mako shark) was the combined outcome of designers Bill Mitchell and Larry Shinoda, while the engine and chassis development was in the capable hands of Zora Arkus-Duntov.

'This Corvette has been a blessing in many ways; I now work to live – not vice versa. A tick on the ol' bucket list was cruising, roof down, to Le Mans to take place in the Parade of the Pilots – being urged by locals to "Rev it, Monsieur!" But most importantly it's been a way of helping, after 14 years of separation, rebuild a relationship with my son. It's enabled us to spend quality time together, such as when we drove to Normandy – four fabulous days together; just father and son. Until the day I shuffle off this mortal coil I'll carry on enjoying the Corvette. And when that day comes the Corvette will be bequeathed to my son – so he tells me.'

'With Mum's hatred of flying, driving holidays were prevalent in our household. Neither were they short trips – France, Spain and Italy featured heavily as holiday destinations. Lengthy journeys on which you appreciate comfortable, generously sized cars – a prerequisite I still abide by. My first car, which wasn't shared with Mum, was an MG Midget. Being a student, a classic car that was cheap to run appealed to me – running costs are not such an important factor nowadays, though. The MG was also from an era that Dad, who worked at Ford, was comfortable tinkering with. However, after several years it was at the point of needing full restoration – but I lacked the time,' explains Tom, a digital effects compositor in the film industry.

'This 1988 signal-red XJ-S became mine six years ago. At that time I didn't know too much about the marque. And with my parents away on a three-month cruise, I didn't have my dad to offer advice. Then again, if they hadn't been away they'd likely have had something to say about the half-share in a bar I also purchased!'

jaguar xj-s

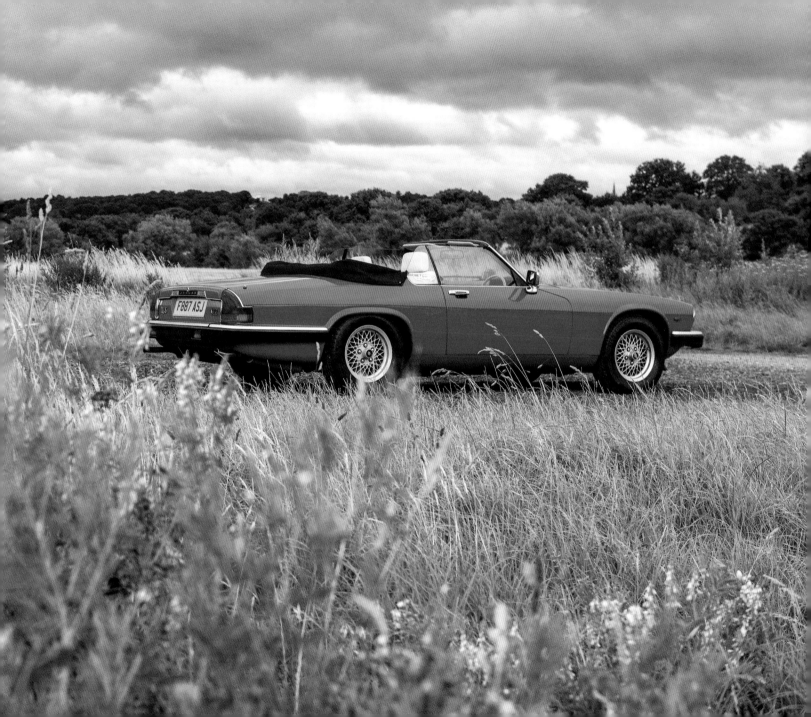

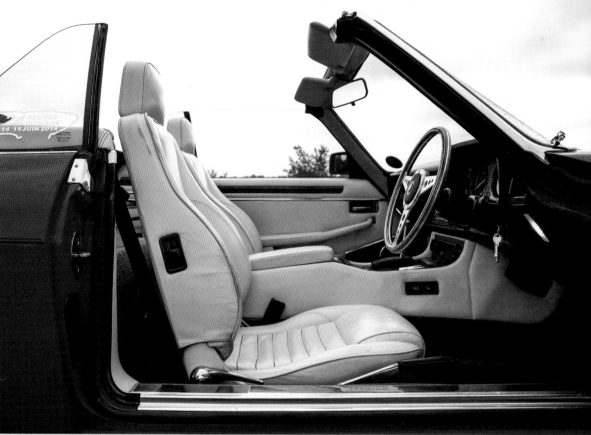

As the last few E-Types emerged in 1974, the XJ-S prepared for its debut in 1975 – with much to live up to. Unfortunate timing resulted in the V12-engined car being launched in the midst of the fuel crisis; it didn't bode well – demand for luxury grand tourers was slim. The initial concepts were the work of Malcolm Sayer, but Jaguar's own design team (headed by Doug Thorpe) took the reins after Malcolm died in 1970. The 1983 XJ-SC targa-top never proved a hit and was superseded by a more successful 5.3-litre V12 full convertible in 1988. In 1991, after a face-lift, the XJ-S became the XJS until 1996, when it ceased production.

'Working in a climate-controlled windowless room leaves you with little idea what it's like outside. So it's a nice transition come Friday, weather permitting, to bring the roof down and let that vitamin D flood in! To facilitate this I joined the Gay Classic Car Club, a demographic to my liking, where talk isn't just XJ-S related – since it's not a single-marque club. The club's membership is several thousand strong and throughout the year arranges group trips to places of interest. Great people and another perfect excuse to use the car. I'd like to think that if I ever needed another car, it would be in addition to this one – this car is rather special.'

'My father was indeed correct; I've had much more owner satisfaction with this type of car. His words of advice led me down the road to handmade cars. Living near to AC Cars' Thames Ditton factory, I bought an AC Greyhound with a Bristol gearbox and two-litre engine. This was 1967, yet it wasn't until 1982 that I bought my first Bristol – a V8 411S4. In 1999 when "10DPG", which was at the tail-end of a restoration, came up for sale my wife, Hilary, thought it would be a canny purchase and a way to wean me from my BMW motorcycle. It almost worked; I bought the car – but still kept the motorcycle. The restoration was completed in 2001 and so began the adventures,' explains Geoffrey, enthusiastic and loyal owner of this 1956 Bristol 405. The marque remains a discerning choice, especially for those who appreciate the relative anonymity of a speciality automaker that doesn't court publicity.

'As part of the Bristol Owners Club we've toured through most of Europe, America, Africa and New Zealand. This prepped us for what we refer to as our wrinkly gap year, which in fact turned into 16 months. In 2010 we shipped 10DPG to Miami and moseyed up the east coast of America to Halifax, Canada. then across to Vancouver, south back through the US and into Mexico, then

10dpg

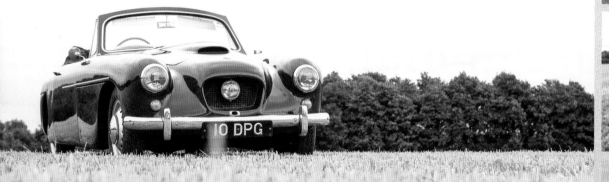

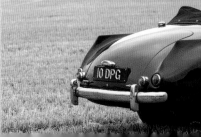

across Central America through Guatemala, El Salvador, Honduras, Nicaragua, Costa Rica and Panama. On reaching Chile (via Buenos Aires) we shipped the car to Australia to take in the sights before she went by sea again to Turkey. From there we drove back to Rotterdam. All the time we were logging exploits of our 33,196-mile (53,424km) journey home.'

Bristol Aeroplane Company was a hugely successful aero-engine manufacturer. After World War Two it established Bristol Cars, producing quality handmade automobiles built to aircraft standards. Only 2,800 Bristols were built, of which 42 were 405 dropheads. Dudley Hobbs, aerodynamicist and Bristol Car designer (including the 405), utilised wind-tunnel technology to assist with his car designs. Unsurprisingly, the lines of the bodywork give a nod to aviation, especially with the rear fins and grille – with its central headlight mimicking an aero-engine intake, the latter housing a spotlight on the 404 and 405.

'The fact that we faced no animosity, damage or theft on our travels rebuilt our faith in humanity. That is, until three weeks after our return, when someone dinged my car and didn't even leave a note, would you please! That aside, since April 2001 we've driven 185,000 glorious miles on our trips.'

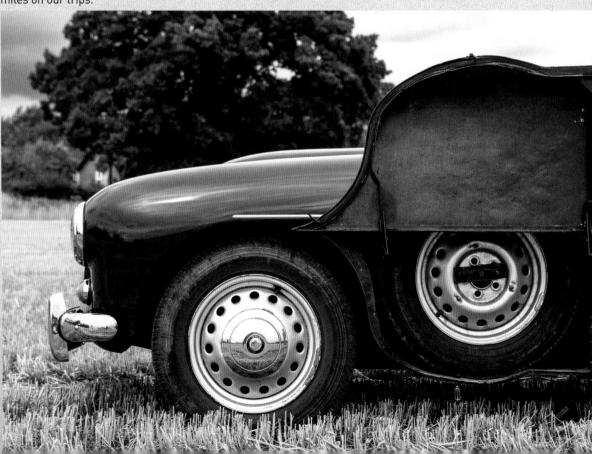

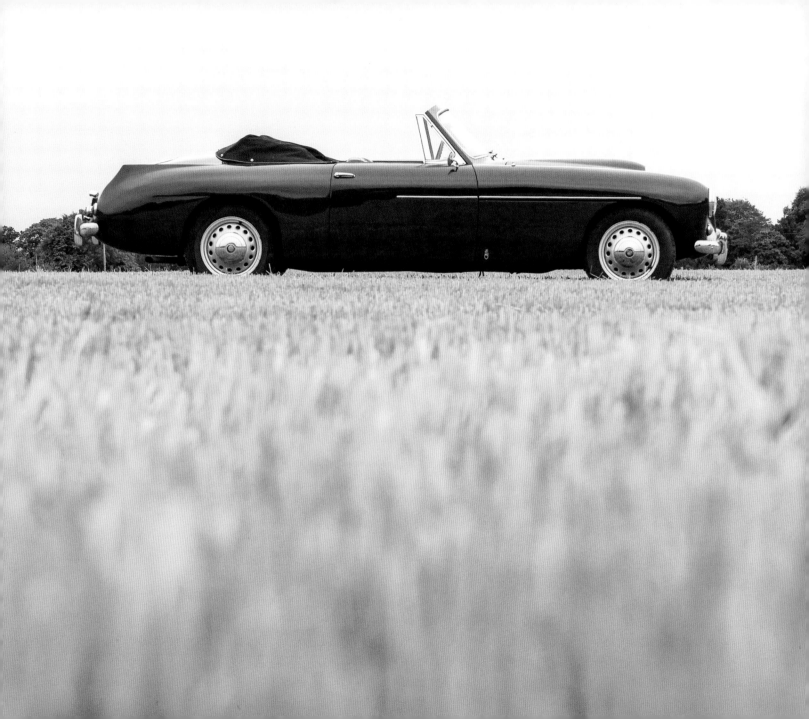

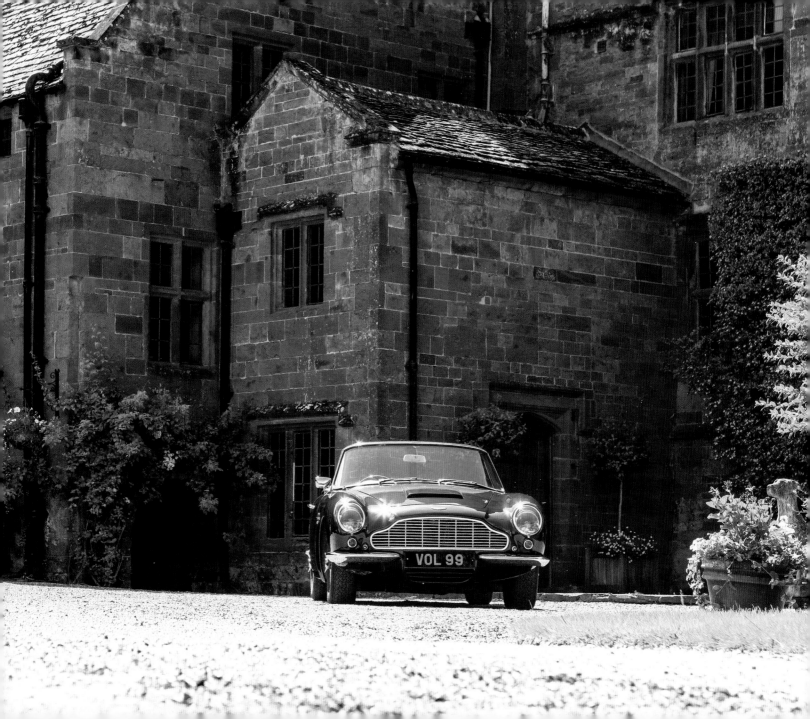

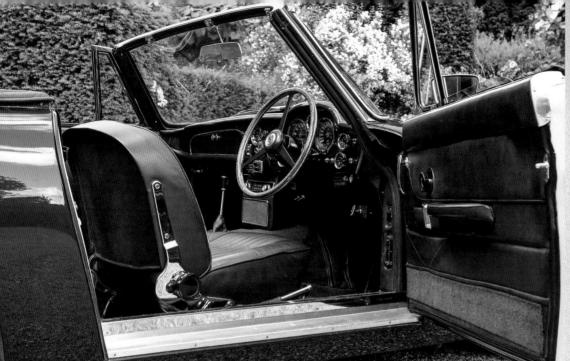

'Learning to drive happens early when your playground is a farm in Wales. Over the months preceding my 17th birthday I tinkered with a weary old Austin-Healey Frogeye Sprite that had cost me £75. The end result, finished in Bahama yellow, helped me win the affections of a young lady. The car didn't last long, but the relationship did; 40 years of marriage to date. On our 25th wedding anniversary I gifted my wife a restored Frogeye Sprite that mimicked every detail (even the colour) of my first car.' For David Richards CBE, the owner of Prodrive (motorsport and advanced technology) with a penchant for the back-to-basics engineering and simplicity exhibited in cars of earlier decades, this was the dawn of his automotive love affair. Yet even any youthful aspirations must have fallen short of his achievements thus far.

'Before long a rationalisation of the classic cars we'd acquired was due, honing it down to four "forever cars": the Sprite; a Morris Minor Traveller; a Frazer Nash LeMans replica for my wife; and an Aston Martin DB6 Vantage Volante for myself. The DB6 was the culmination of a childhood dream. I'd lusted over the marque for years – the racing pedigree and glamour was infectious. However, in the early '90s fine examples were scarce and prices had sky-rocketed. I was early for a meeting one day and to kill time I had a browse around a classic car showroom. Among an array of interesting vehicles was a tarpaulin-covered car. Full of curiosity, I had a peek beneath, which revealed a MkI four-litre straight-six DB6. It had apparently suffered an under-bonnet fire while on a demo drive. As it was on sale-or-return the garage insurance didn't cover the damage and the owner's insurance had lapsed – a year had passed with no resolution in sight. I contacted the owner and negotiated a deal to buy the car "as seen", then

aston martin db6 vantage volante

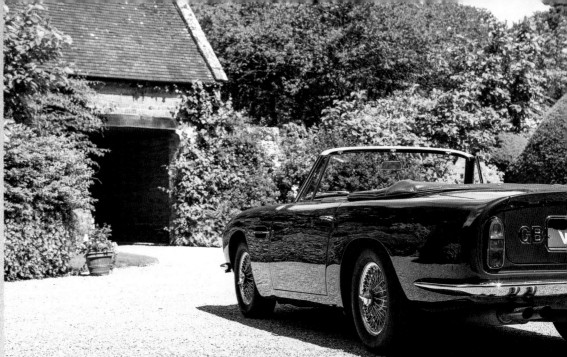

took it straight to Victor Gauntlett (then head of Aston Martin) and asked if he'd carry out a ground-up restoration. Aston Martin, was a little light on work then, so he willingly agreed.'

Aston Martin was founded in 1913 by Lionel Martin and Robert Bamford. When the company fell on tough times post-war, saviour and entrepreneur Sir David Brown (hence DB) purchased the company for £20,500 in 1947. The DB6 was produced between 1965 and 1971 with a total of 1,967 units.

'A new millennium saw the launch of the DB9, along with an agreement that Prodrive should develop the DB9 to compete in international sports car racing, including Le Mans – a team I headed. In 2006 over dinner with an American banker we discussed Ford's decision to sell Aston Martin. Knowing my enthusiasm for the marque it was suggested I should buy it. However, the little matter of a billion dollars stood in the way. But with the help of my American banker we raised the funds and I headed a financial consortium to purchase the company. One year later I was chairman of Aston Martin.'

David has never regretted taking a chance on his first – and much cheaper – Aston Martin purchase. 'My DB6 Volante has become part of our family. Since the recent royal nuptials it's also become the wedding car of choice for friends of my children. In fact we've a wedding kit on hand, L plates and all, to mimic the look when Prince William emerged with Kate from the gates of Buckingham Palace in his father's DB6 Volante, which is virtually identical. In my opinion cars should be used and mine has been extensively, with tours of Italy and Scotland, and it's routinely my choice of car to commute to work, with the roof down in the summer.'

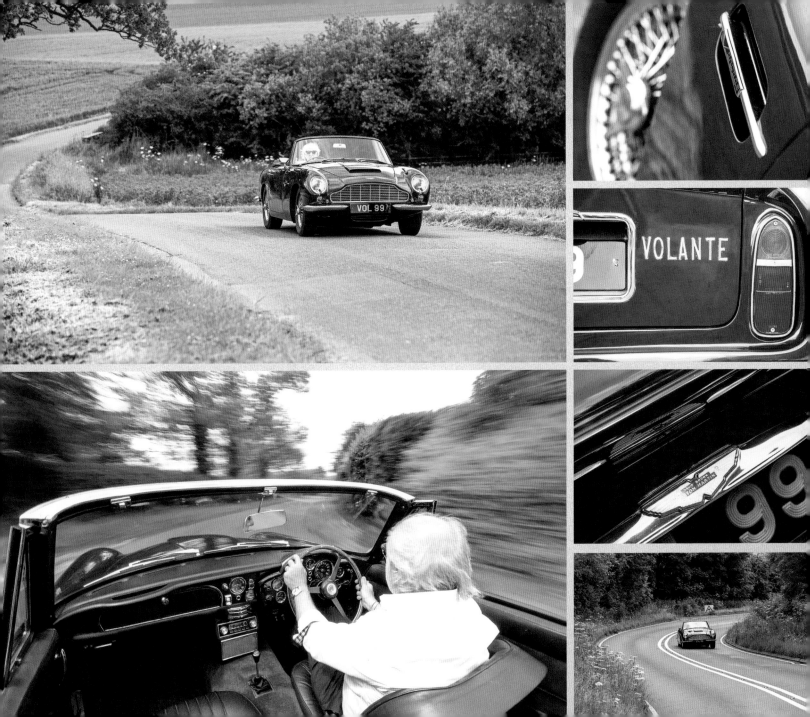

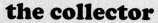

the collector

'My father, Enzo, owned one of the oldest garages in the city of Bergamo in northern Italy. Seeing that he catered for older cars, my appreciation for modern vehicles never developed – hence my own personal project, aged 14, a Pininfarina-inspired Alfa Romeo Giulietta Spider. And soon after followed an Alfa Romeo Giulia Spider of historical importance, seeing that it had completed the 1990 Carrera Panamericana – a border-to-border racing event on open roads in Mexico. With my love of cars it was obvious the direction my life was going to take,' explains Daniele, who went on to evolve his passion for collectable cars into a business, becoming a collector and facilitator to help introduce others to the world of collectable cars.

'These were my first real collectable cars. We'll gloss over my first car – a Fiat 500 that I managed to put on its roof, having had my driving licence for only three hours. Henceforth it was safer to get my kicks in rally driving and Motocross. This in turn developed into a love of circuit racing with historic cars, Formula Junior and touring car racing with a Lotus Cortina.

'A highlight of my collection thus far has to be the alluring steel-bodied Fiat 1100 Barchetta based on the Fiat 1100 by Italian Pietro Frua. It's believed to be the only one in existence, as well as the first car designed by him.' Pietro Frua (1913–83) was a true master in the history of automotive design. His professional career started when employed as a draughtsman at Farina. By the age of 22 he'd worked through the company to become Director of Styling. After the war Frua established a design studio in Turin and over the years set about creating some glamorous car designs – including the Renault Caravelle, BMWs and a host of Maseratis.

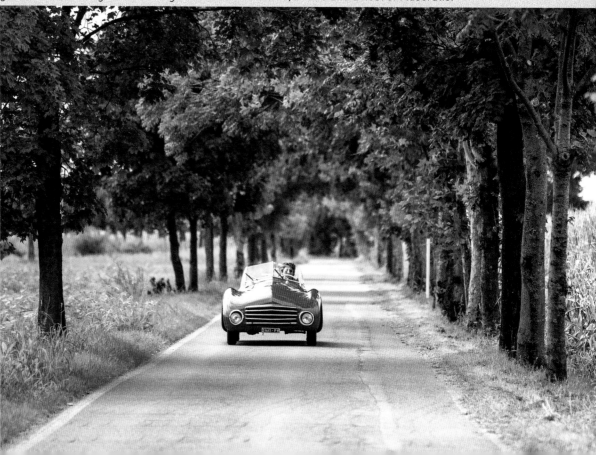

'For obvious reasons I easily succumb to Italian sports cars, so this hand-formed aluminium 1952 Bandini Siluro, with a screaming 750cc engine, was no exception. Bandini Automobili was an Italian automobile manufacturer operating between 1946 and 1992. This torpedo-shaped car had raced at the Bologna passo della Raticosa hillclimb before it left for America, where it was raced for many years, returning to Italy around ten years ago. I'm forever tempted by new possibilities to add to my collection – it's the nature of my business. However, for the moment I'm more than content with this diminutive but immensely rewarding duo.

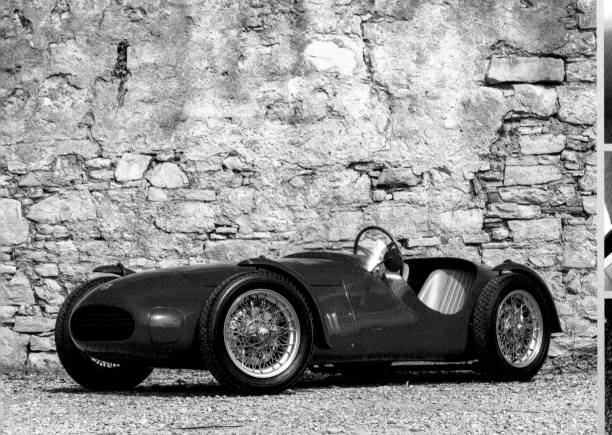

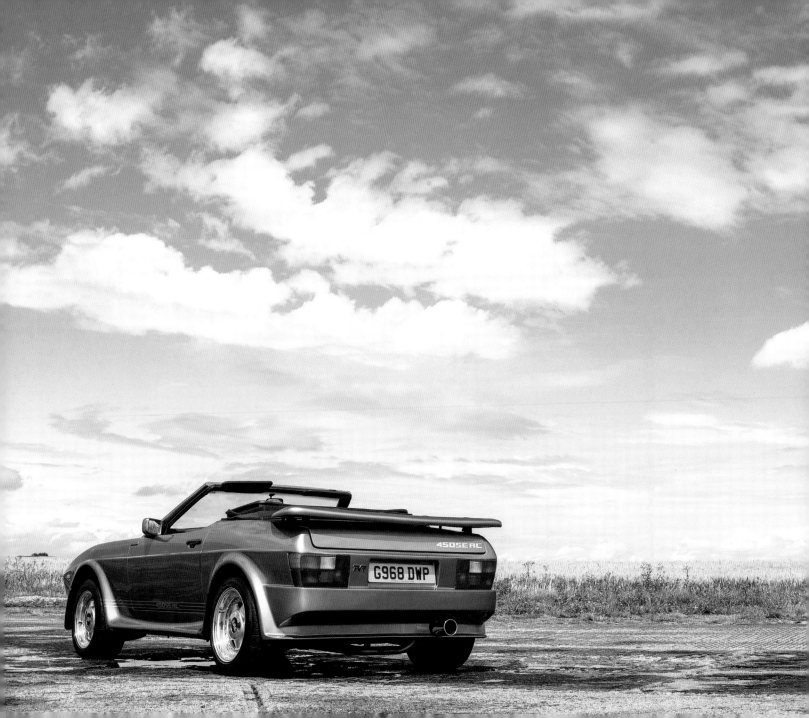

evocative

The retro-styled cars of the type that appear within this chapter might, at first glance, seem to be culturally outdated. However, in my opinion that would be a short-sighted view. In their own way each of these cars was a step forward in automotive design. But if we still have to agree to disagree they will, if nothing else, evoke memories in the majority of you – both good and bad. Memories of individualistic style statements from manufacturers not afraid to utilise hefty quantities of interior plastic; and obtuse-angled body panels made from Kevlar, carbon-fibre and fibreglass. Not forgetting the eye-popping colour combinations and questionable but glorious paint jobs.

Within this chapter an opportunity will unfold to savour a selection of iconic vehicles; as well as appreciate why the owners are proud of their vehicles and hold them in such high regard. Like the Saab owner keeping on the right side of his father-in-law, or an owner for whom no setbacks will halt the love of his VW Golf. There's a Talbot Samba in a condition that can only be described as beyond immaculate; yet its owner still finds the time, outside of his cleaning routine, to enjoy the car to its fullest. You'll find an owner with a serious wedge problem of the triumphant kind, and a marque of car that was once the butt of many jokes. However, the owner's resilience won through and he's now title-holder to a car of very few numbers.

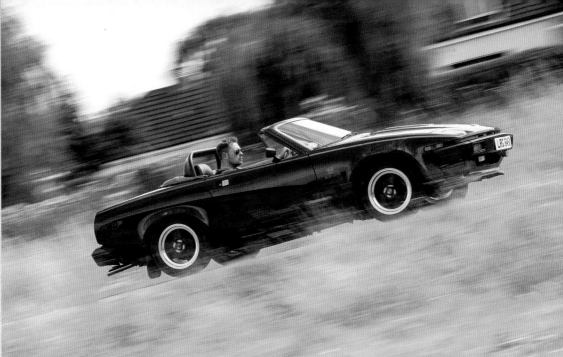

wedge

'Number 13: unlucky for some – not for me. With this my 13th Triumph I consider myself fortunate. Try as I might, I can't get TR7s out of my system: 8-valve, 16-valve, V8, roadster and coupés – all flavours. With product placement on primetime TV, the TR7 left a lasting impression on me. It looked amazing, yet under the skin it was oh so conventional. Even among the wider Triumph community people tend to look down on wedge-shaped TRs. In my opinion they've never been given the respect warranted. However, I'm the kind that roots for an underdog; in my view it's as good as anything out there – with styling that sets it apart,' explains car salesman Darren, a man who, in a world of harmoniously shaped cars, enjoys owning something that's so instantly identifiable.

The TR7 was manufactured between 1974 and 1981 by Triumph – part of British Leyland – and marketed as 'The Shape of Things to Come', reflecting the car's wedge shape, credited to Harris Mann, with a swage line sweeping from front to back. America embraced the TR7, dubbing it the British Corvette. To capitalise on sales the standard engine was upgraded to a V8 and badged the TR8. However, the relative strength of the pound against the dollar at the time made Triumphs expensive compared to competitors.

'My first TR7 was 21 years ago,' says Darren. 'Back then it was not so much a classic – just something quirky. The latest in my arsenal is this TR8 in Bordeaux red with clashing blue plaid. Actually it started as a TR7; however, the previous owner (who was handy with a socket set)

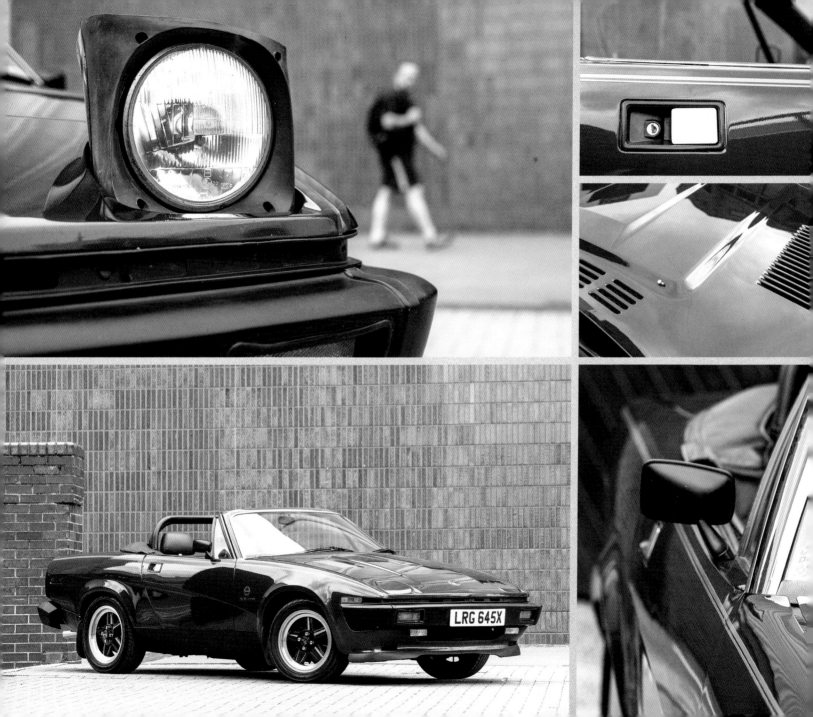

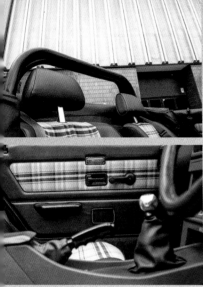

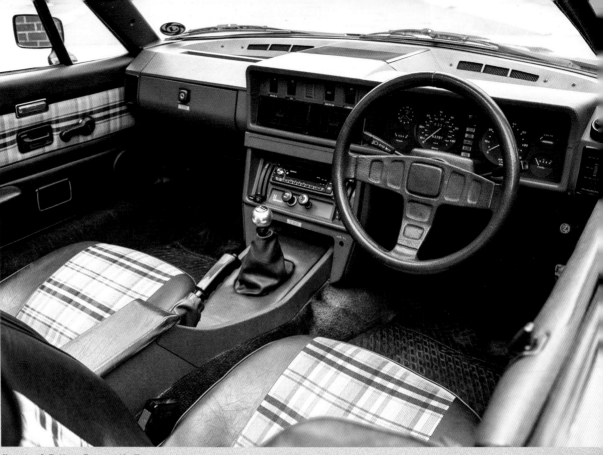

fitted a 3.5-litre Rover V8. For good measure he changed the gearbox, back axles, suspension and brakes, begging the question why he didn't get a TR8 in the first place. When I'm up for some banter I drive the car to work. Some colleagues get it; others hurl playful insults. It's an age thing; digital versus analogue generation – I'm somewhere in the middle.

'Life's short and if you wanna tick those "had that" boxes you've gotta get a shift on; so cars work themselves in and out of my life at a pace. Yet this one's lingered longer. For me, three years is a serious automotive commitment. My girlfriend's a singer, out gigging till the early hours at weekends, so I'm left to my own devices – giving me an ideal opportunity to head out and stretch the car's legs.'

'Preparation for life as a family man involves compromises. Selling my Ford XR3 in exchange for a Ford Orion 1.4L was a concession too far – I loathed it. In 1993, on the eve of my 28th birthday, I bought this 1987 MkII Vauxhall Cavalier convertible. Although not entirely practical for impending fatherhood, it was a happy medium and the 1.8 SE 8-valve fuel-injection engine deemed acceptable by mates in the hot hatch fraternity. Despite the car being only six years old, I started exhibiting it. In 1994 it won best Cavalier convertible at the national rally,' explains Tom, aircraft engineer and owner of this '80s retro classic.

'Eventually with work and family commitments the car never got a look-in. I didn't want or need to part with it; its value at the time was negligible. Gradually it was mothballed and over the years taken from one place to another whenever we moved house. It wasn't until I was on the cusp of turning 50 that life plateaued sufficiently, with my boys now in their twenties, that I could afford time for a hobby. I didn't need to look far – the ideal candidate was waiting in the garage. My Cavalier, in beautiful helios blue, was unearthed and brought back into service.

vauxhall cavalier

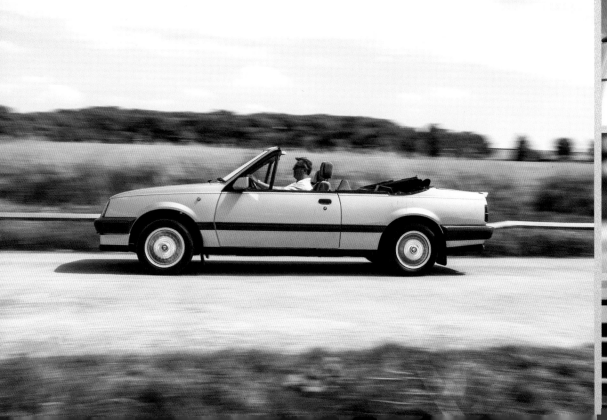

'It remains a car that's never truly been in vogue and probably never will be. Another car of the same ilk and era would be appreciating at a greater rate. Yet, despite only having a comparatively small value, I've shelled out significantly more than its worth to bring this slice of retro back to show condition.'

It was Vauxhall's intention, with the Cavalier convertible, to compete with the BMW 3 Series convertible. Since Vauxhall never really had a two-door Cavalier for the UK market, they based the design on an Opel Ascona two-door. This kept production costs down, which was helped further by skimping on luxuries: no electric windows, no power steering and a manual hood.

'It's ironic that I've spent over a quarter of a century building and maintaining aircraft, only for my forte to become dismantling them to keep others airborne. Sadly Vauxhall never built this car with longevity in mind – it was the era of planned obsolescence. Probably 50 remain on the road, with the same again left in various states of repair. In a strange parallel of my job I'm seeking out examples of my car that are beyond saving, but salvageable for parts – that way, I can keep my car and memories of my twenties alive. Memories rekindled by motoring along, roof down of course, blasting out the prerequisite '80s classics on the stereo. Someone once said to me, "I didn't know you had a classic car in the garage?" To which I replied, "It wasn't a classic when I put it in the garage!"'

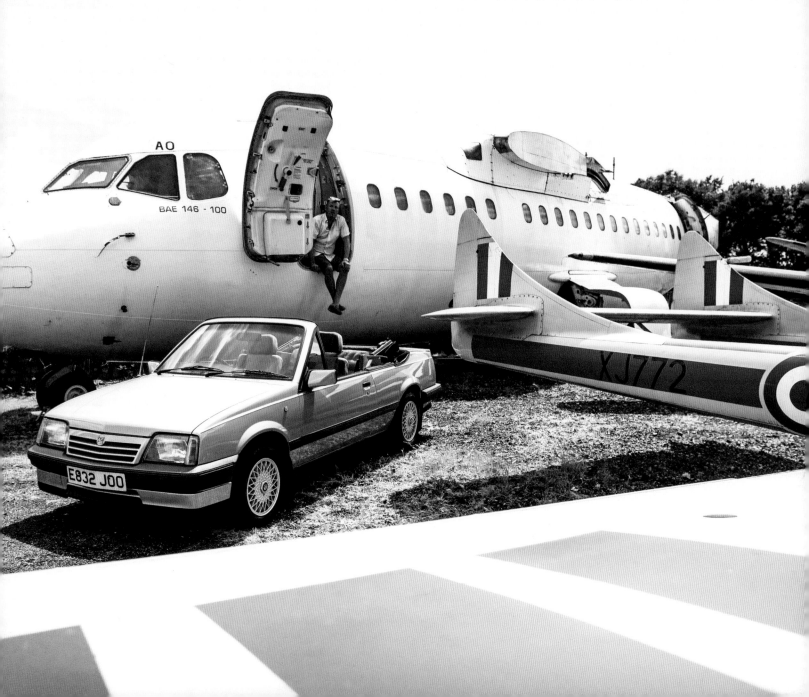

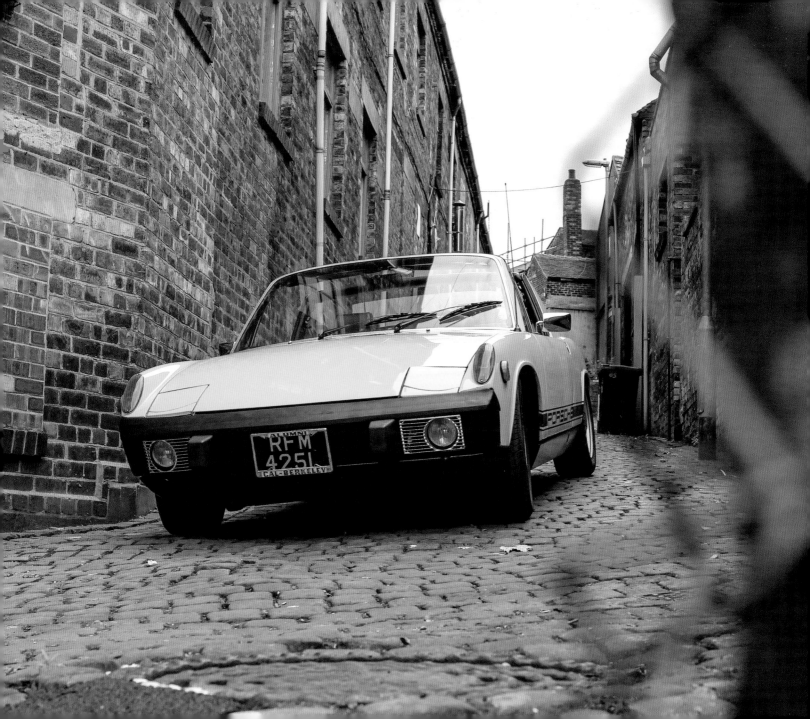

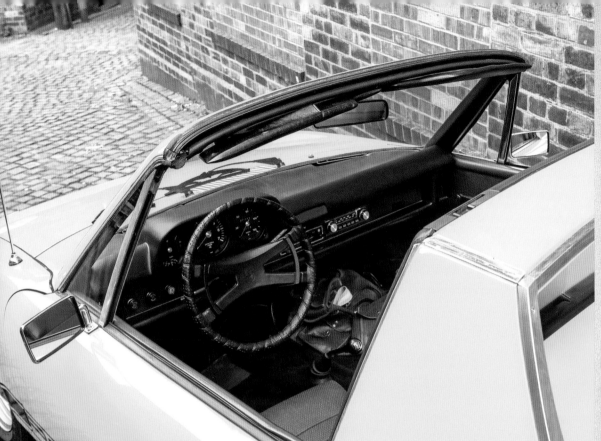

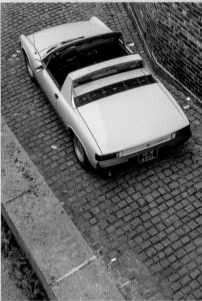

'I'm picky about design and details; it's something drummed into you during a career in film and Liverpudlian soap opera production,' explains Andy. 'Another mantra I firmly believe is that vehicles are time-stamps of their era; evoking feelings, good or bad, about cultural trends at that time. This has resulted in me owning a number of design-rich cars: a VW 181 Thing, Karmann Ghia, Pontiac Fiero, Nissan Cube, I even owned a VW split-screen fire engine – not that I imagined myself putting out fires. This inherent narrative leads me to dwell upon owning these cars during their moment on the timeline. One particular car I've lusted over, since the '90s, is the Porsche 914 – the lovechild of two automakers hailing from the same country.'

In the late 1960s the time was ripe for Porsche to replace their 912; a not dissimilar situation existed for VW and their Karmann Ghia. Therefore VW executive Heinz Nordhoff and Ferry Porsche joined forces to build a sports car for the masses. Porsche provided the design and VW the engine, and a verbal agreement was formed that each would have their own badged version of the car. The first prototype of the mid-engine, fuel-injected, targa-top

california dreamin'

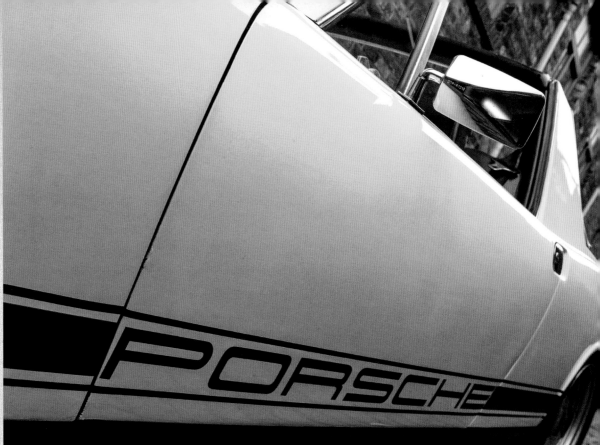

914 was presented on 1 March 1968. Problems ensued a month later when Nordhoff died; his successor, Kurt Lotz, had no ties with the Porsche dynasty, so the verbal agreement was quashed. Therefore, in Europe it was known as the VW-Porsche 914; but in America it was simply a Porsche. Yet, Porsche aficionados were the 914's biggest hurdle. With all of its VW components, they deemed that it wasn't a true Porsche.

'As is the way nowadays,' continues Andy, 'I spotted my Porsche 914 for sale online. In that instant my heart and rationale were already on their way to Cyprus to hand over the money. However, as luck would have it, a mate was in Cyprus, celebrating his wedding anniversary. Despite the absence of an interlude appraising Porsches on his

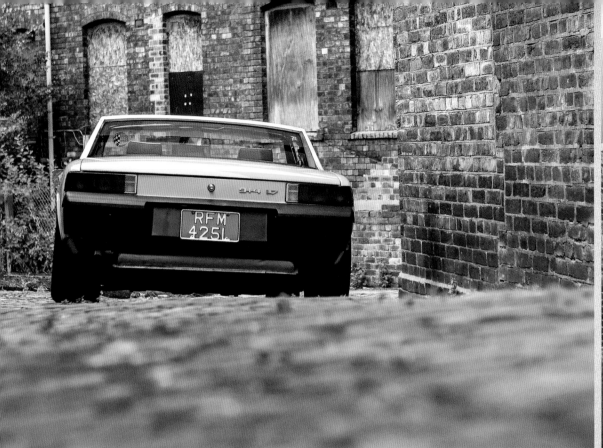

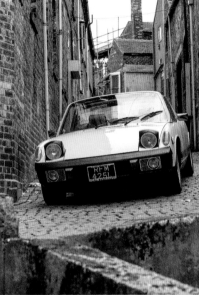

itinerary, he kindly agreed to take a look and give me his honest opinion. To my relief it was genuine and owned by a Greek Cypriot who, although living in California, would ship an occasional car from his collection over to Cyprus to sell – and sell it he did. Once all the loose ends of importation had been tied up, the car was mine to bring home. The narrative is strong with this car. And if I try really, really hard I can almost imagine myself driving along the Pacific Coast Highway – albeit on the Rock Ferry bypass between Birkenhead and Hooton.'

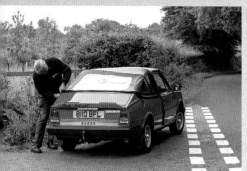

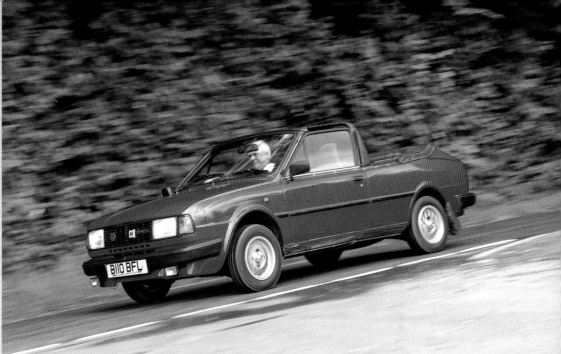

skoda rapid

'To be honest, I knew little about Skodas. Nor did I have the money or time to give over to classic cars. However, I was certainly tempted when a neighbour brought home his Skoda cabriolet – and he knew it. He enticed me further by gifting me a Skoda Owners Club membership and inviting me on a club tour of Germany – 350 cars from all over Europe, some dating back to the 1930s. It worked; the following year (2003) I bought myself this 1985 Skoda 130 Rapid.

'Tigger, my car's nickname, is a labour of love. It's cost me a small fortune, especially considering the value of the car. However, when all is said and done it's my hobby and a price can't be put on the pleasure I get from it,' explains Colin, ex-military policeman and owner of this rapidly disappearing piece of iconic Czech engineering. According to Colin's research, Skodas of the pre-VW era have diminished dramatically since 2000. Then 52,000 rear-engine Skodas were registered; by 2014 it was down to 190 – with certain variants in single figures.

Skoda's roots were planted in Bohemia, now part of the Czech Republic, in 1895 by Vaclav Laurin and Vaclav Klement, who initially designed and built bicycles. The addition of engines to their bikes was soon followed by their first car. It was a roaring success and in order to build upon this the company merged with Plzen Skodovka Co. in 1925 and became Skoda. Until the '60s they were renowned for producing a handsome range of vehicles, yet in the years that followed the build quality was questionable. Although Skoda's reputation was tarnished, the rear-engined Rapid (1984–90) was a significant improvement. The convertible was for the UK

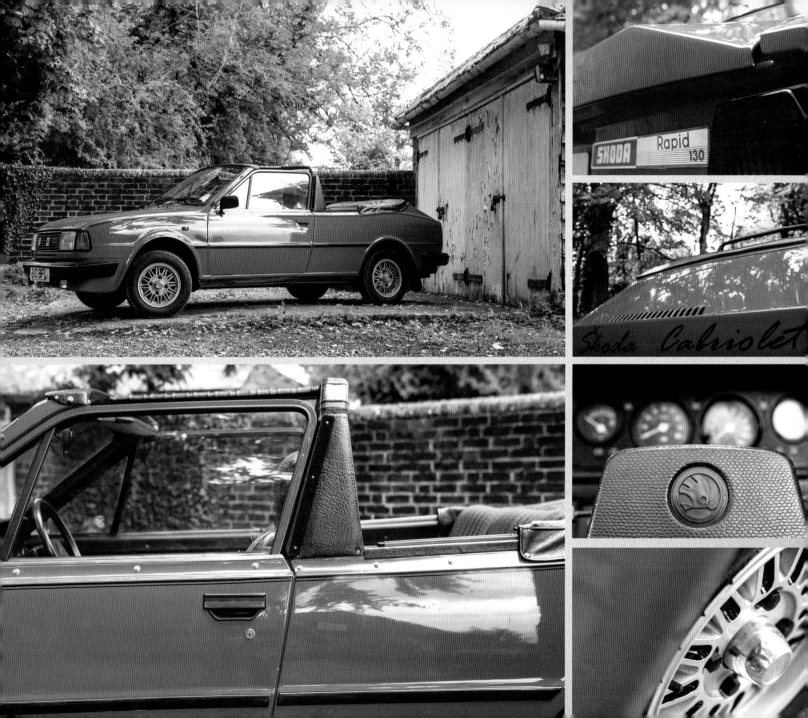

ŠKODA Rapid 130

Škoda Cabriolet

market alone and converted by Ludgate Design & Development. Of the 330 conversions, there are now only 13 accounted for and 7 taxed on the road as of 2015.

'Those of a certain generation can't resist a jibe at my car; calling it a skip and expecting me to laugh as if it's the first time I've heard it. It's water off a duck's back to me; most of the jokers don't realise the heritage of Skoda and certainly not the stunning cars they once built. It's a bit of a faff getting the roof on and off – Velcro and snap-fasteners galore – so when the roof's down it tends to stay down for the duration. That explains the purple upholstery, which should in fact be black – discolouration that's all down to the sun. It's not the fastest thing on four wheels, but it sure does put a smile on my face.'

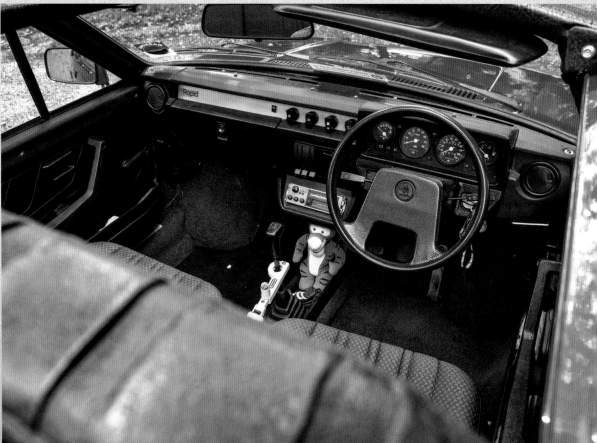

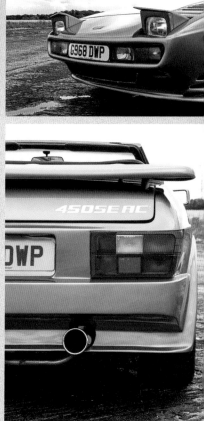

tvr 450 seac

'The 450 SEAC stands out as one of the most formidable-looking cars of the '80s and '90s, as well as heralding the culmination of the Big Bad Wedge era – something TVR became renowned for. Its legacy lives on and still divides opinion. Initially, I too didn't embrace the new-fangled shape – chiselled by the instigator of all things wedgy, Oliver Winterbottom of Lotus Elite fame. Instead, in 1980, my preference was a curvy TVR 3000M. I managed to bypass the whole '80s angular TVR craze; then, after a ten-year hiatus, I reacquainted myself with TVRs in the '90s – with a succession of curvaceous TVR Chimaeras and Cerberas,' explains owner Andy.

'In 2000 my business, recommissioning military tanks, took a dive – having lost several lucrative government contracts – and sadly a TVR was a luxury I could ill afford. After a few years in the doldrums, my wife encouraged me to go and get a TVR – I couldn't let the lady down. So I bought a relatively cheap TVR 350i – a project car and the start of my fascination with 1980s TVRs. With nine in my collection, it's apparent that my hostility towards wedge-shaped '80s TVRs is firmly in the past.'

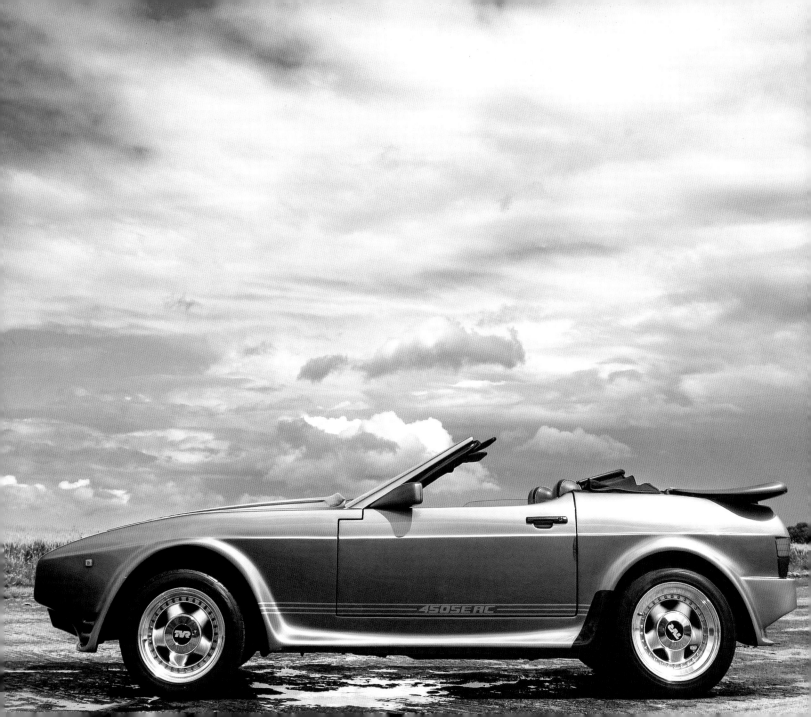

TVR Engineering of Blackpool was founded in 1947 by Trevor Wilkinson and Jack Picard. Up to 1949 they carried out general mechanical engineering, before embarking on the creation of their own chassis and subsequent curvy bodyshell by Les Dale. By 1953 only three cars had been produced, but they gained notoriety by winning sprints and hillclimbs. In 1953 a new chassis was developed with the sole purpose of selling it as a kit. The kit was composed of Austin A40 components and a fibreglass RGS Atalanta bodyshell. Although produced in small numbers, this was to be the first car that TVR produced and advertised. Henceforth TVR grew to become the world's third-largest specialised sports car manufacturer.

'Considering they're rare as hen's teeth, my 450 SEAC was a lucky acquisition. With two years of production, 1988 to 1989, only 18 were made. The 450 SEAC (Special Equipment Aramid Composite – Aramid Composite referred to the bodywork made of Kevlar, carbon-fibre and fibreglass) was designed to be strong, light and, with a modified 4.5-litre Rover V8, earth-shatteringly fast. It's without doubt my favourite wedge TVR; the whole concept – luxury and power – is intoxicating.'

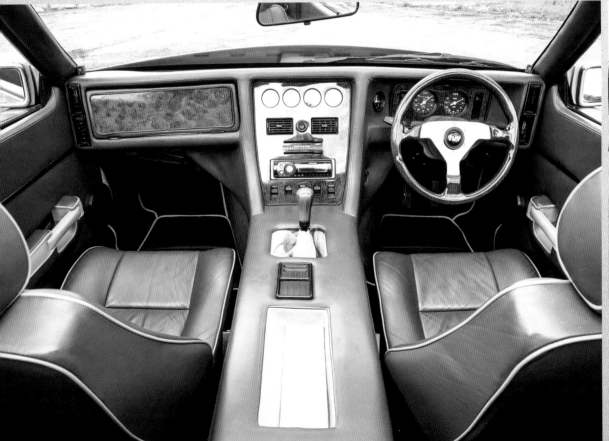

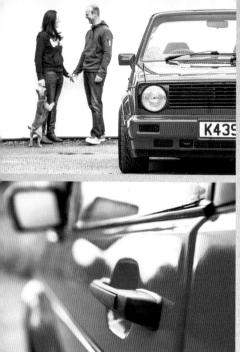

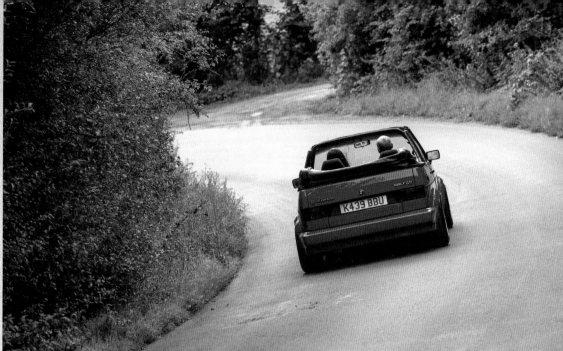

the bean

'I'm often asked why it's named The Bean; well, it started when Andy, a colleague, took me out for a spin in his Mk1 Golf – even as a passenger it was amazing; I needed one in my life! A flick through the classifieds unearthed a reasonably priced but unloved 1993 Sportline Golf. Andy was rounded up and off we went to check it out. The moment I clapped eyes on its cloudy faded red paint and experienced that cosseted feeling from the factory standard Recaro seat, I knew it was the one for me. However, the engine noise was somewhat underwhelming; it had suspect suspension and a clutch pedal that nearly dislocated your hip – but who doesn't love a project? It was sold right there and then. To my amazement it made it home and so began the ritual of patting the car and uttering, "well done!". Enamoured, I broke out the polish and, sure enough, beneath that pink skin was a red car! And with help from a specialist it soon sounded like a GTI ought to – the beginnings of a small fortune ploughed into the car,' explains Toby, owner of the Bean since April 2000.

An early trip was, appropriately enough, to a car show. 'It transpired that driving there would be far more entertaining than anything exhibited. When, 20 miles (32km) into the 120-mile (195-km) journey, I had to carry out the mother of all emergency stops, instead of that restrictive feeling, as the seatbelt tightens, the pedal just hit the floor! When the car eventually stopped I got out, had a cursory look underneath and reported to Andy, who'd come along on the jaunt, that all seemed fine. "Shall we head back home?" he replied. "Nah," I said, "we'll just drive carefully and use the handbrake." Upon arrival, and once the tension that had manifested itself in the form of a very sweaty back eased, a high five was given to my co-pilot and the Bean received its usual praise.

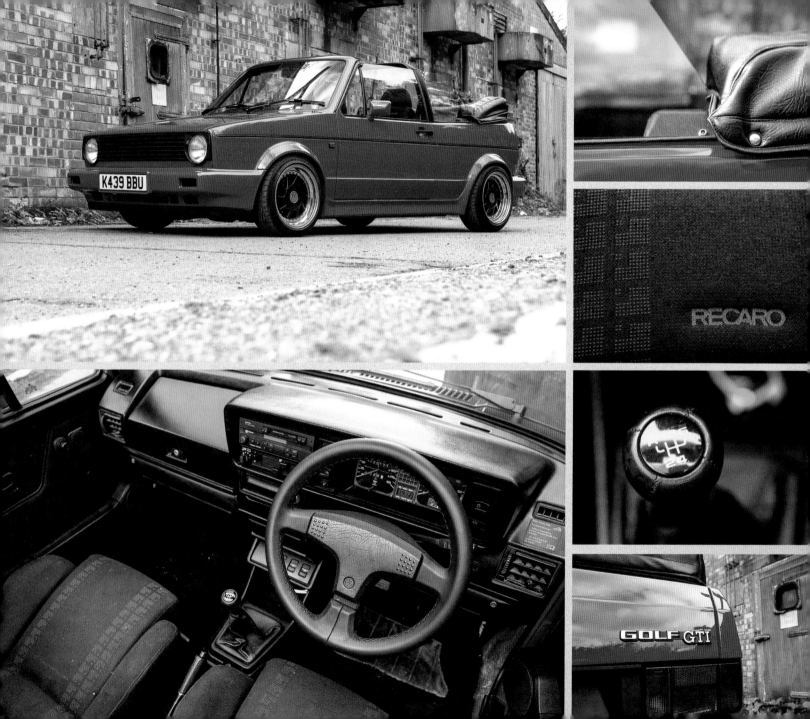

'We were apprehensive about our journey home; we'd every right to be. Cue biblical rain while on the motorway – with the roof down, of course. We watched helplessly as water travelled up the windscreen and slapped us in the face like a wet cod. Since the roof would only activate with the engine off, we hunted for a safe place to stop. With the roof up it was no longer raining inside the car; however, we and the interior were soaked. Heaters on full bore seemed the logical choice. Cue the next problem: steam – it looked like some seriously illicit action was taking place! As if things couldn't get worse, not forgetting the iffy brakes, the near-side wiper blade bent double! Without hesitation, my wingman rolled down the window and climbed out to retrieve the rogue wiper. We somehow made it home in one piece and, yes, I did give the Bean its obligatory pat and "well done!".

From the onset I've had *big* plans for the Bean and, over what's been a long and at times treacherous journey, they're finally nearing completion. But – my girlfriend Debbie aside – the car means the world to me. Many people have asked to buy the Bean, and the answer is never a "No"; just a wry laugh and shake of the head – silly people. And in answer to why it's called the Bean, I don't know – it just is.'

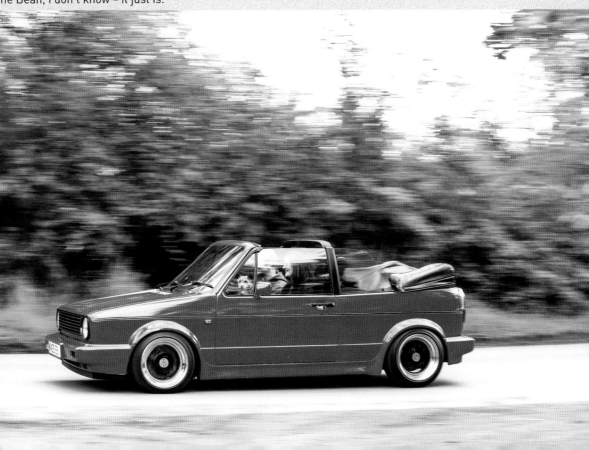

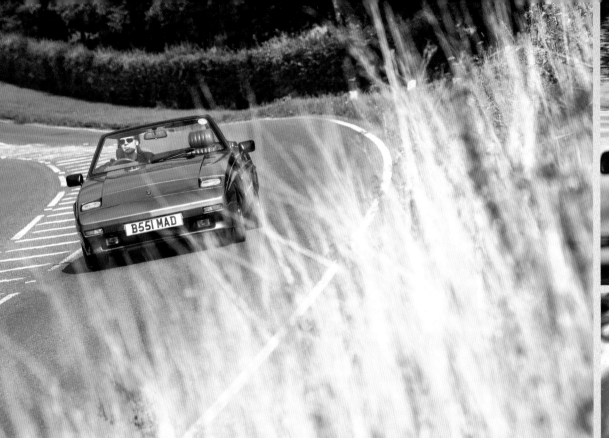

reliant scimitar ss1

'Owning a Reliant Scimitar SS1 really is rewarding, once you've put aside the taunting – "Oh, that's the kinda car Princess Anne owned!"; "Don't they catch fire and melt?" – ignored the panel gap tolerances measured in how many digestive biscuits can be inserted (one being OK, two not so good) and resigned yourself to the fact that, at some point, you'll smell of hot fibreglass and have itchy arms. In fact, these factors, plus my love for an underdog, just increase my affinity for this plastic oddity.

'It started for me aged ten when I phoned to confirm that a classified ad for a three-wheeled Reliant Robin van was indeed £25 and not, as my father assumed, a misprint and £250. My parents are liberal-minded, so a few days later (with a ramp designed for four wheels, not three) we manhandled it onto the trailer. After a few months' work it returned a healthy profit, which went towards my goal of a Scimitar SS1. That, with help from my father, who was keen for me to move on from my Reliant Robin obsession, I reached age 11,' explains Philip, owner of this '80s British roadster that never quite came to fruition.

In the early '80s, with no other British roadster manufacturer as a competitor, it was a golden opportunity for Reliant and their SS1 (small sports). With a Lotus Elan-inspired

chassis and styling by Italian designer Giovanni Michelotti, its future seemed secure. However, Michelotti's vision was never quite finished; this was to be his final design before his death in 1980. Without him it was left for others to interpret his concept. Despite great aspirations the hype fell short of expectations when it was launched, under the Scimitar brand, in 1984. The lacklustre 1.3-litre engine and huge development costs sealed its fate. Despite plans to make 2,000 cars a year, only 1,507 in total were ever produced.

'I've weak heartstrings when it comes to Reliants in need of rescuing. It's meant that, with all the restorations and subsequent sales, I've managed to own 32 SS1s. I've ticked off all variants of the SS1, including the 1800Ti Turbo, a phenomenal car – what the initial SS1 should've been.

'After part-exchanging with a Reliant Kitten, this 1.3-litre SS1 became mine in 2008. It's rather special to me, seeing that I passed my driving test in it. However, the driving instructor was less than enamoured by my car – he couldn't wait to vacate it. Since then it's been my daily drive; been on the aggressive end of 1,200 track-day miles (1,931km); has accompanied me on a 3,000-mile (4,830-km) trip to southern Spain and back; and been adorned with ribbons and balloons for my wedding day. The SS1's rarity does throw up a few interesting assumptions – "Nice Triumph!" – and from a petrol attendant, who might have been facetious: "Is that a Lamborghini?" Recently we celebrated the 30th anniversary of the SS1; and while I've never really regarded the car as a classic, it may hopefully in time be recognised as one.'

'A Saab, why?' That was my opening question to Richard, owner of this Swedish design icon.

'Well,' he replied, 'aside from keeping on the good side of my father-in-law (who's currently on his 37th Saab) I'd like to think I'd have ended up owning one anyhow – or six, as it's turned out – just because they're such great cars. My continuing interest isn't to appease my father-in-law; just simply that once you're introduced to the world of Saab there's no returning. It's difficult putting a finger on exactly what it is...yes, there's a soupçon of aloofness to the marque – but more likely that it taps into my wanton disregard for normal characterless cars. If you're gonna drive, you might as well do it in something you like.

'Wafting along, roof down, with the turbo making itself known – it's really a rather special place to be. You feel cocooned within the ergonomically designed environment; controls, dials and gauges are all positioned in order of importance, thus minimising the driver's averted gaze. I can wax lyrical over the many clever innovations the marque is renowned for. However, all this attention to detail came at a cost; an eye-watering price tag when new! This gave rise

the family way

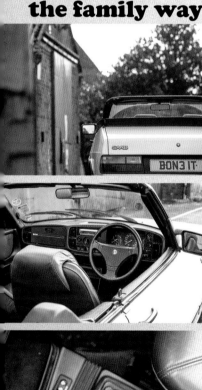

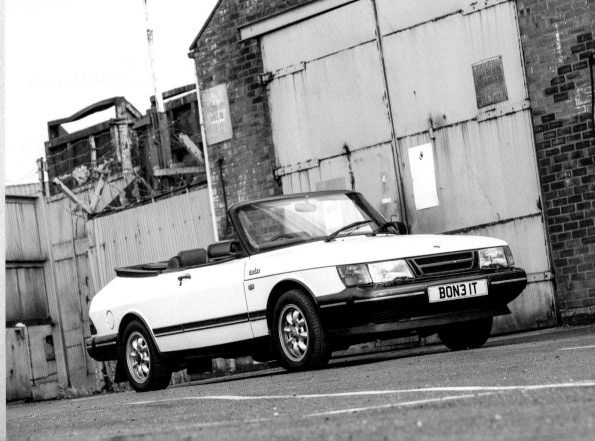

to the perception that it was only doctors and architects who drove Saabs.' The Saab 900 was produced, in two generations, from 1978 until 1998. The 900 convertible was conceived by Robert J. Sinclair, President of Saab-Scania of America, who suggested its introduction would boost sales. The prototype was exhibited at the Frankfurt Motor Show in the autumn of 1983 and aroused so much interest that Saab pushed the car through to production in spring 1986 – ultimately exceeding predicted sales.

'As many testify, the costs involved in owning what is quickly becoming a classic often go beyond the value of the car. Sure, it's been a shrewd investment; even if we quickly gloss over the past three years of garage bills. However, in the scheme of things it's still relatively cheap, but hugely rewarding, motoring. That's something I'm quick to preach to others and thus far have converted two sceptics over to the marque – another feather in my cap as far as my father-in-law is concerned.'

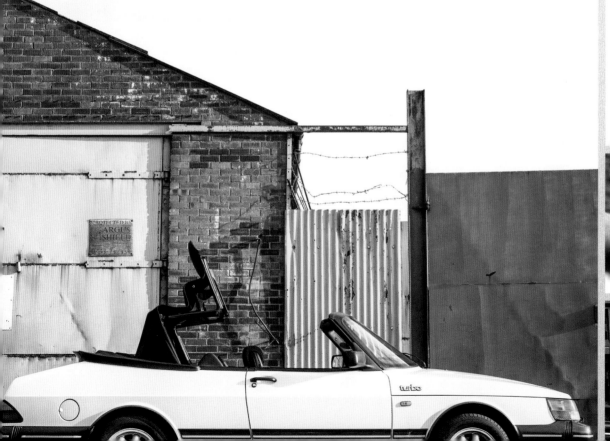

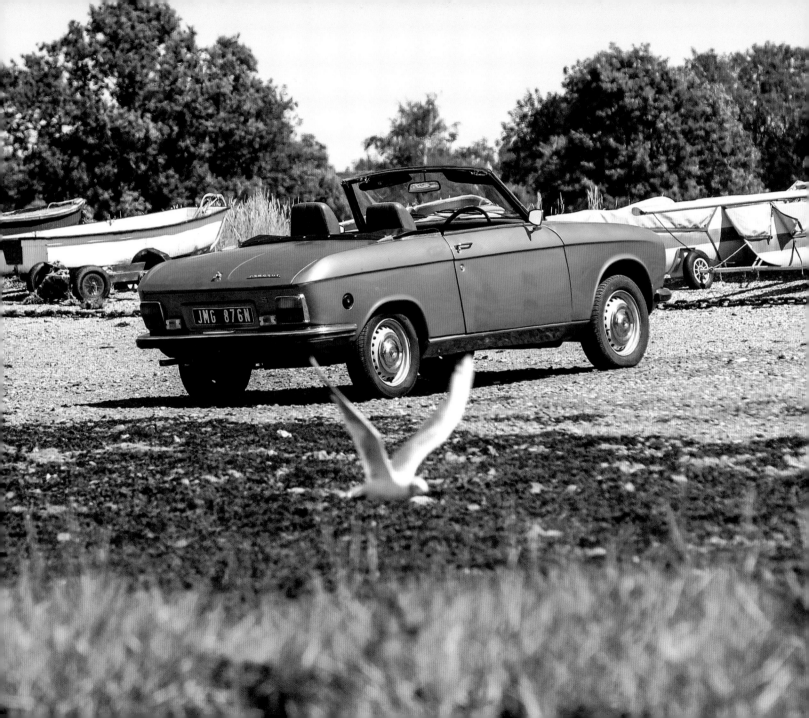

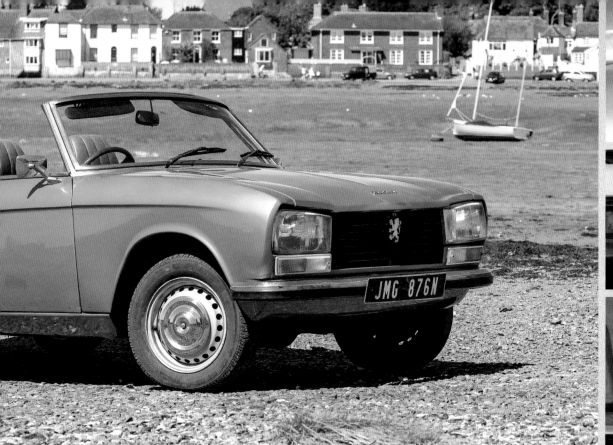

peugeot 304

'While other children were finding out what the story was in Balamory, my son William was reeling out, with impressive accuracy, car marques as we drove about town. I'm happy to go along with his obsession; as I guess any loving dad would. However, three years ago, to abate William's pestering I succumbed and agreed to buy him, albeit in my name (since he was only 12), a 1975 Peugeot 304 Cabriolet – his long-time favourite.

'A reason so few of these cars remain roadworthy (23 last time I checked) is that a) our inclement British weather rotted many, and b) 304s beyond viable restoration became donor cars. In fact, to get the car to its present condition (don't look too closely) has been with the benefit of two donor cars. One we bought from a scrapyard as it waited to be crushed, and another that had suffered an electrical fire and been left to rust was given to us (in exchange for a bunch of flowers). Many times we've considered the viability of this project. But we've persevered and, although much still needs to be done, we'd rather get out and enjoy the car,' explains Mark, dad and chauffeur to his son.

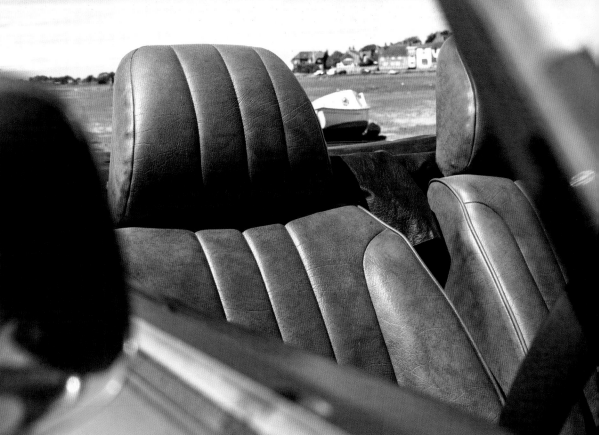

The Pininfarina-designed 304, with its six body variants, was advanced for its time and proved successful for Peugeot; 1,178,423 were produced in total (between 1969 and 1980), of which 18,647 were the Cabriolet (1970–75). The stylish Cabriolet was also the first of the 304 range to receive the sprightly 'S' 1.3-litre 75bhp engine.

Will continues: 'I appreciate the styling of today's models; but in spite of that I'll often bypass stereotypical sports cars – especially if it's blocking my path to something quirky from the '70s or '80s. I seem to have an uncanny knack of finding those cars, which has led to me building an appreciative internet audience that take delight in seeing my photographs of forgotten motoring classics. I'm counting down the days, if only to give my dad a break, until I can drive the 304. However, with no power steering and a gearbox like stirring a bowl of soup, maybe I'll take my driving test in something that gives me a fighting chance of passing.'

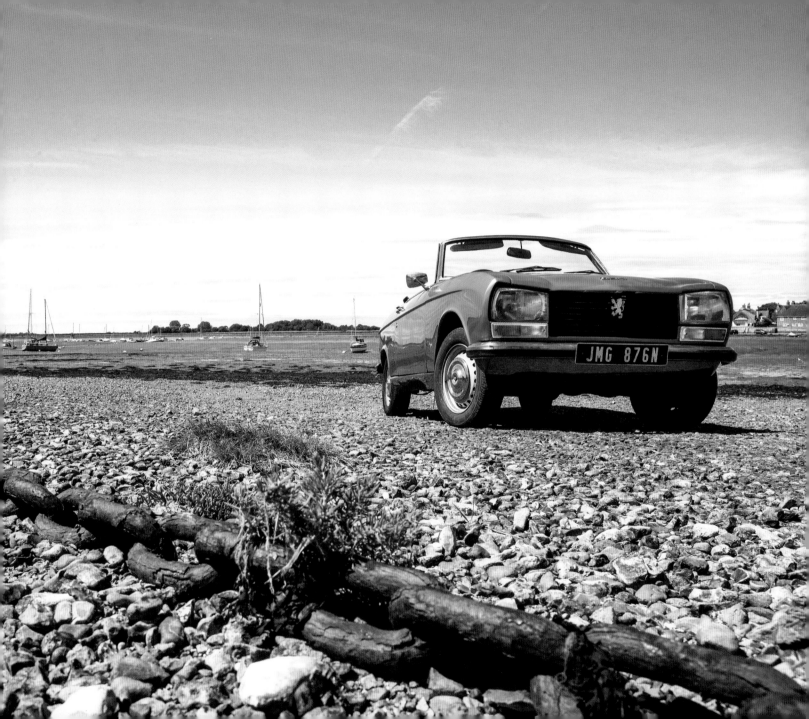

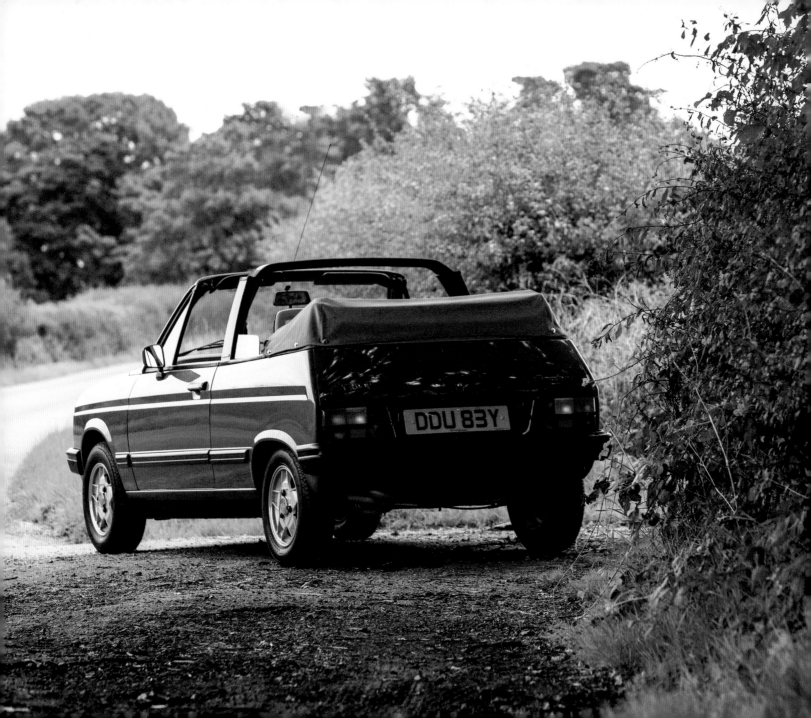

'Car cleaning has been a way of life ever since I acquired my first company car in 1980. If sloping off to give the car a quick shammy during one's lunch hour seems extreme, how about shelling out money from your own pocket on a set of chrome eight-spoke wheels – surely I'm in the minority who'd upgrade their company car?' comments Terry, who in 1987, with a desire for a cheap convertible, settled upon the Talbot Samba.

'Aside from sitting neatly in my price bracket, the Samba was practical; well specced; styled by Pininfarina and with its 1360cc engine could propel itself from 0–60 in 12 action-packed seconds! As the years rolled by the Talbot marque became a scarce sight on the road; the rarer they became, the more my appreciation grew for my own Samba – as did my love of car detailing. Cleaning and detailing cars are two different kettles of fish: the first is a typical Sunday morning ritual, whereas the other's a shiny ticket to a world of automotive cleanliness where detailers, such as Larry Kosilla, share tips and tricks online and are placed on pedestals – with rock-star status! To give you an insight, we're talking about deionised

talbot samba

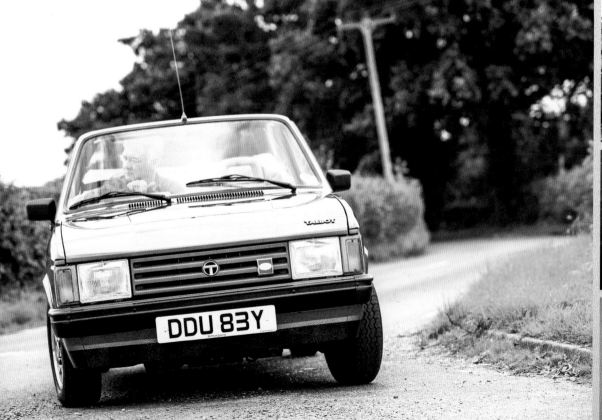

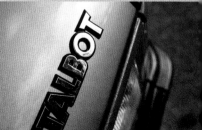

room-temperature water; two-bucket cleaning (wash/rinse); microfibre cloths; brushes; clay; buffing; and a polish for every surface of the car.

'I bought this prime Talbot Samba back in 1996. It once belonged to the Patrick Collection – a collection started in 1960 by Joseph Patrick (head of Patrick Motors) that at its peak totalled 240 vehicles. Often they'd exhibit a top-of-the-range car, with only delivery miles, which is why mine has amassed only 5,187 mollycoddled miles (8,348km).

'My standards have slipped recently,' admits Terry. 'I don't take part in as many shows as I used to – therefore the car's at an eight out of ten. Bringing it back to concourse level, so a judge's probing finger would emerge clean from every nook and cranny, would require a deep clean taking several months. Spending £150 on a pot of polish might sound excessive; but to me it's irrelevant that I'm lavishing so much time and money on a car that some would deem isn't worth it. With a cult following and approximately 40 left in the UK, I'd be mad to part with my Samba – besides, who'd want to take over my fastidious cleaning regime?'

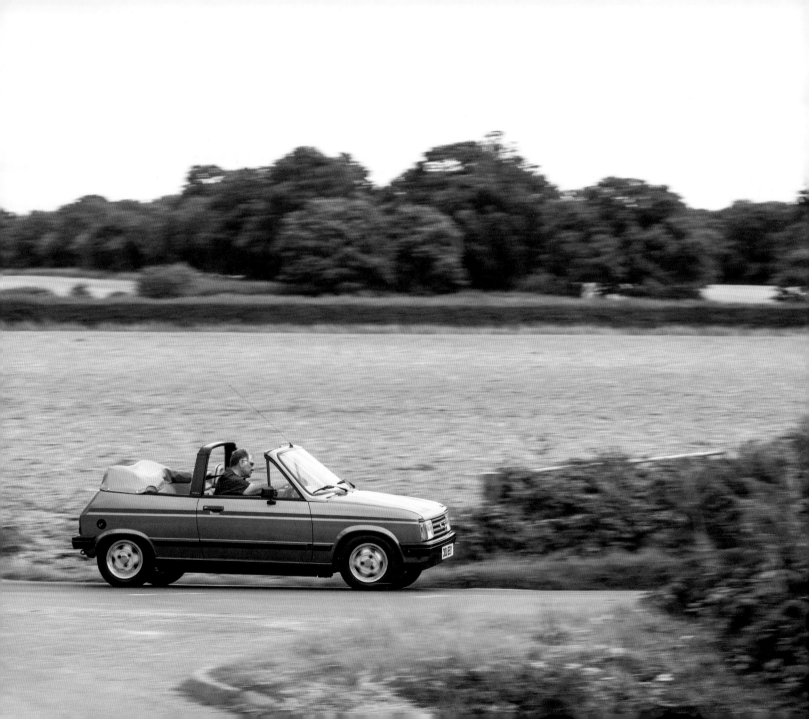

individual

This is a chapter which, as the title suggests, has a broad scope for inclusion. Whether it's the style, size, condition or modifications, there's something refreshing about sidestepping the ordinary and embracing individuality through what can sometimes be classed as eccentricity.

In this chapter we celebrate individuals who push aside conformity, such as a vehicle more suited to the sand dunes of California but enjoyed endlessly on a daily commute. Another owner has the best of both worlds: a car that made a splash, in more ways than one, when it leapt into action. There's a perfect example of patina, as shown on a Ford Model A Roadster that was rescued from a Californian barn after nearly 60 years. Good things come in small packages, as illustrated by a Nash Metropolitan, and a Westfield Eleven proves that if the original is unobtainable, then a replica is the next best thing.

As well as giving us something offbeat to admire, such owners should be commended for their idiosyncratic choices – at times pushing the boundary of what is termed 'convertible'. This in turn influences and encourages others to follow suit with their own strand of non-conformity. As Graham Chapman urged in Monty Python's *Life of Brian*, 'You're all individuals.' Why not go out and prove him right?

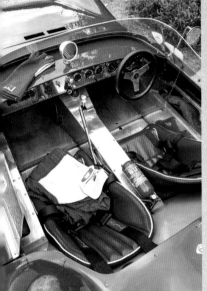

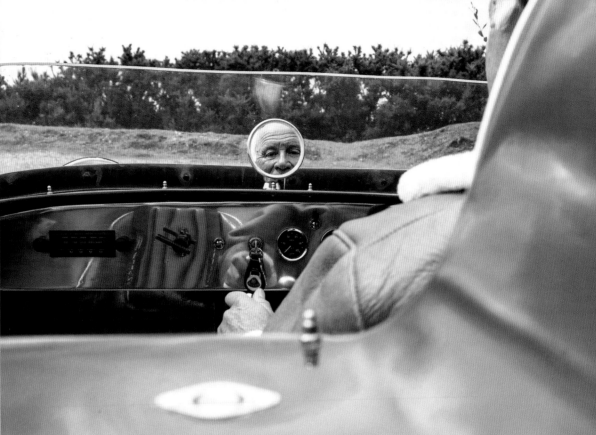

westfield eleven

'July 1965: that's when I began to fall for motorsport's allure. That trip to Crystal Palace later resulted in a stint as a motorsport photographer, until August 1976, when a Formula 2 car slammed into the track wall where I was standing. Four months later I returned to work, but I'd lost my nerve. It wasn't conducive to taking great pictures to have one eye looking down the viewfinder and the other checking my peripheral vision. My career may have been extinguished, but it didn't quell my passion.

'Eventually, with grown-up children and retirement on the horizon it was clearly time for a sports car, so I indulged in a humdinger of a Caterham Seven. However, I wasn't done; I'd set my sights on a Westfield Eleven,' explains Chris, owner of this early-'80s replica of the acclaimed Lotus Eleven. Beneath the aerodynamic fibreglass exterior is a space frame, with ancillary mechanicals – engine, gearbox and so on – supplied from a donor vehicle, usually an MG Midget or Austin-Healey Sprite.

'If it wasn't for a forum thread, I'd have waited far longer than the year it took to find my Westfield. My Westfield Eleven (one of 138) was built by Ray Concar, an engineer working at Westfield. Ray wasn't averse to loaning his car to motorsport journalists,

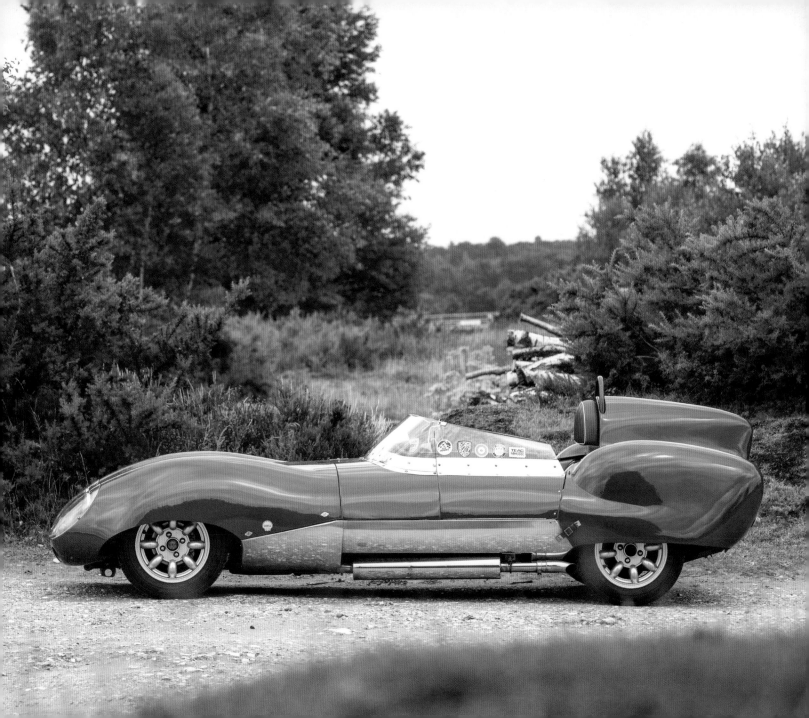

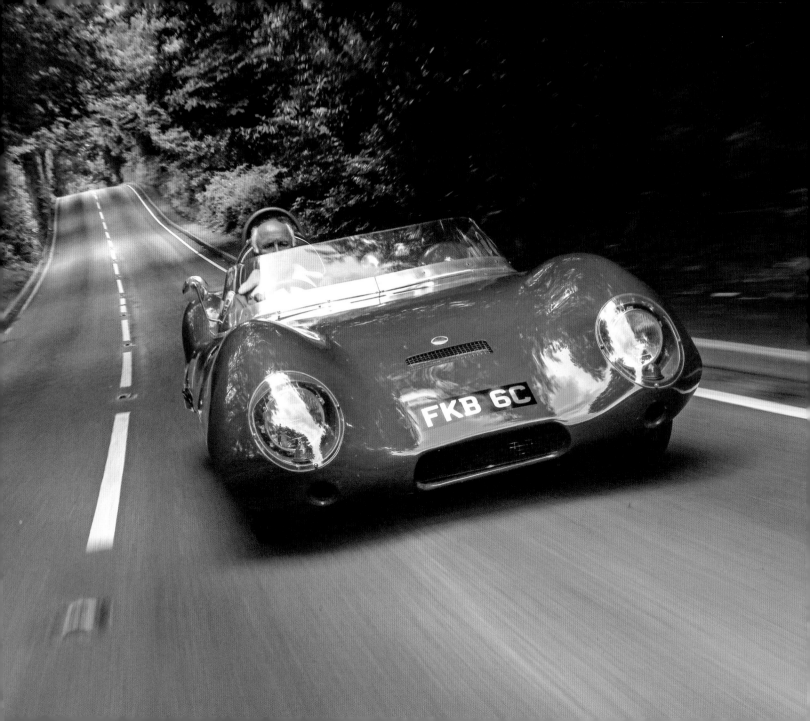

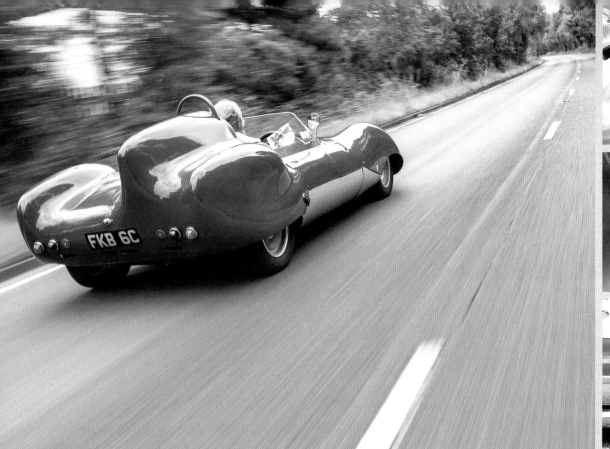

as well as seriously quick racing drivers. When Ray retired from racing, the car was removed from the limelight – that is, until Peter Shaw purchased and set about converting the Westfield into a road car. Sadly Peter, whose first love is racing historic cars, couldn't commit the time to complete the project. But his loss was my gain when I purchased the car in 2007, as he'd undertaken the majority of the expensive work. The fibreglass bonnet was far thicker in places, having been repaired several times during its racing career. For this I was grateful when, on its first outing, a deer appeared from nowhere, landed on the bonnet and ricocheted over the car!

'Replicas are now OK – not the dirty word they used to be. My Westfield may recoil at the sight of speed humps, have minuscule storage, a limited turning circle, pointless doors, a 120-mile (193-km) range and a decibel rating of 108. Yet, with the wind punishing my face as it deflects around the rear clamshell, I wouldn't want to be anywhere else! Plus, on a winter's day I can bring a frozen pasty up to edible temperature from the alloy above the exhaust. We often meet up with Peter Shaw at Brands Hatch – he always remarks how he wishes he'd kept the Westfield. Sadly for him I'm keeping this until I'm unable to clamber into it.'

'To be honest, I can't imagine driving anything else. It's not your typical practical classic; however, in the 12 years since I built mine, and using it as my daily drive, I've covered 115,000 miles (185,075km). That figure has accumulated from year-round use; even in the thick of winter I'm warm as toast thanks to my electrically heated clothing. There's something magical about the car; it's (1,323lb) 600kg of fun that never fails to put a smile on my face – let alone others who witness my daily commute,' explains Peter, an engineer and owner of this Meyers Manx beach buggy. 'I guess for me the "fun" in fun motoring started about 30 years ago. An off-road Baja Bug took my fancy, so I bought a 1954 oval-window VW Beetle (they were ten a penny those days) and set about it with a jigsaw. The end result, despite lacking the sand dunes of southern California, was everything I'd hoped for and more – I kept it for years and eventually sold it to my brother only so that I could start customising Minis.

'Beach buggies helped define Californian beach culture and I'm lucky to have met the man behind the concept: engineer, artist, boat builder and surfer Bruce Meyers. After penning the

beach buggy

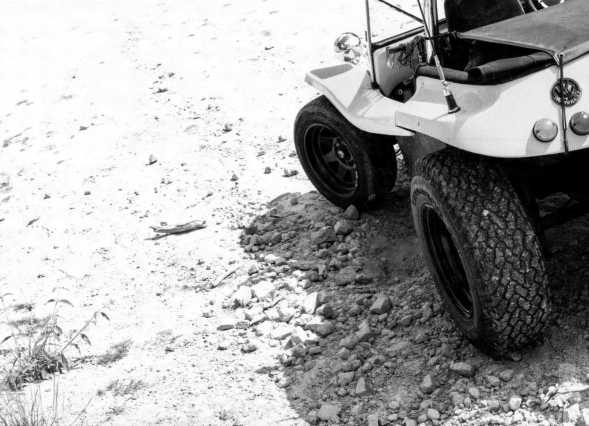

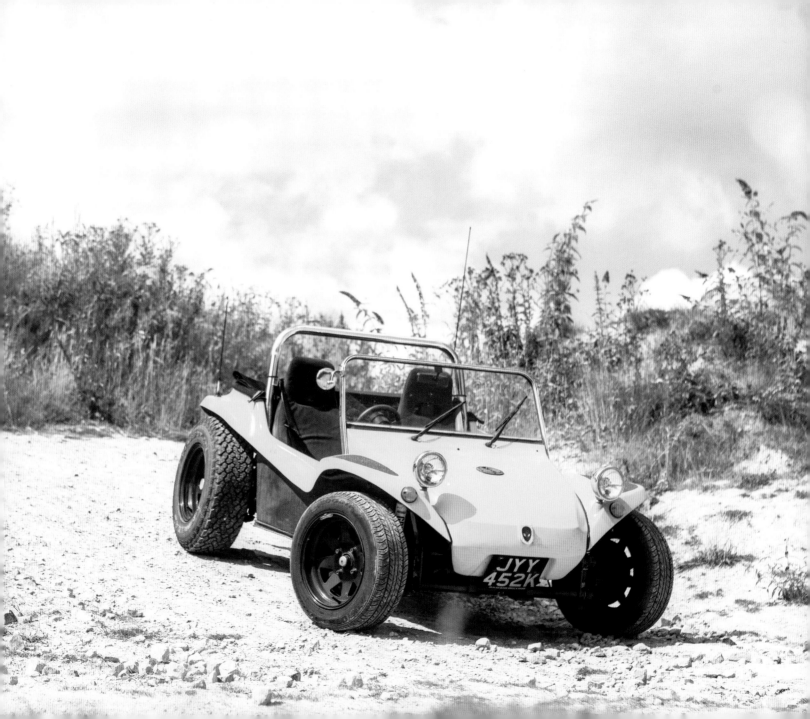

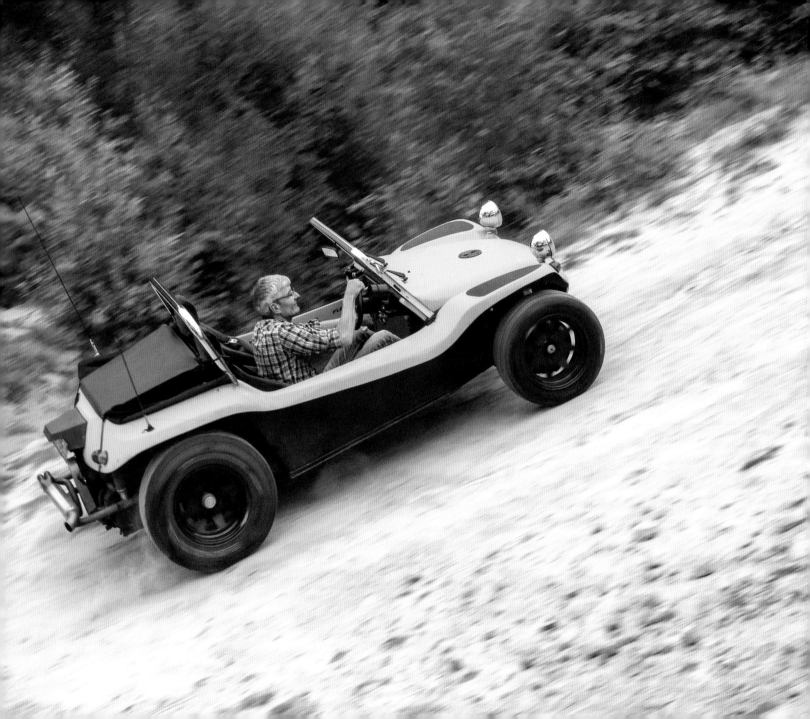

idea for a small, but capable, recreationally oriented automobile he produced 12 monocoque prototypes in 1964–65. The initial buggy proved expensive – so he struck upon the idea of utilising a shortened VW Beetle chassis to accommodate the shell. The rest is history, with over 300,000 examples of his original concept thought to be in existence. In 2014 Bruce, now in his late eighties, attended a VW show and, since my buggy is a licensed kit from Mel Hubbard, he graciously autographed my car – a real honour.

'This fibreglass tub is a big part of my life. However, the prices that these vehicles and others in the VW scene are achieving is borderline mad. It prevents the majority from enjoying the scene in favour of a minority. I'll never part company with it – it's just too much bloody fun! They'll have to dig a bigger hole for me.'

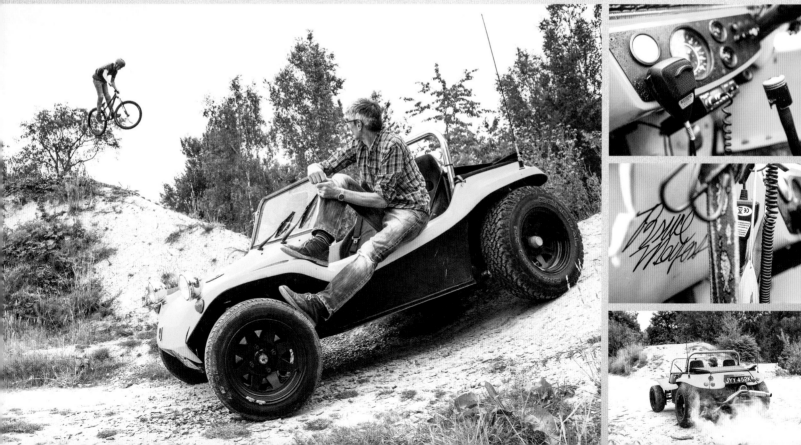

mishmashmepompom

'At the time it was beyond my means, but that wasn't reason enough to stop me gawping through the window of a classic car showroom at a Nash Metropolitan – its kitsch looks were an instant attraction. Seventeen years ago, when I'd finally got the funds together, I realised my dream and bought one – albeit a restoration. However, despite my best intentions, a restoration it remained for about eight years – I never even drove it. A friend, who'd probably grown tired of my excuses, told me his son had (unlike me) just finished restoring a Nash Metropolitan. He kept badgering me to buy it and thus bypass my own faltering project. To deliberately tempt me, he parked the Nash in my driveway. A bold move on his part, but it worked – it never left,' explains danceaholic Myia, owner of this characterful quirk of automotive history.

While the majority of American automobile manufacturers were obsessed with the philosophy that 'bigger is better', Nash Motor Company saw fit to offer a more modest, economical option. America lacked experience in building small cars; therefore it was deemed viable only if built in Europe. In 1952, after negotiations, Austin Motor Company and Fisher & Ludlow (which later both became part of BMC) were announced as manufacturers. For the first time in history a car designed and marketed in America was entirely built in Europe. All production from 1953 until 1957 was designated for export to America. After then Austin marketed the car in the UK as the Austin Metropolitan, until production ceased in 1961.

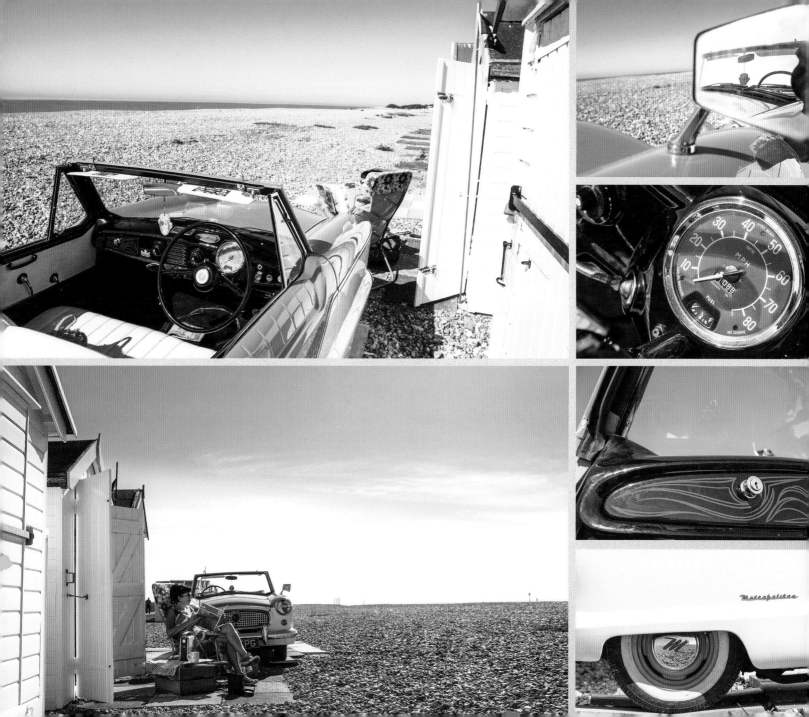

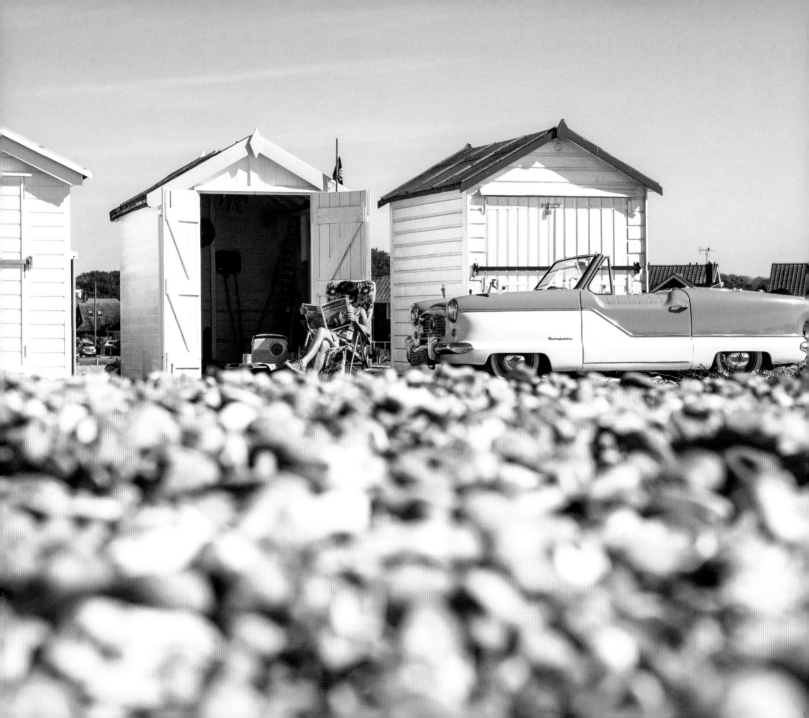

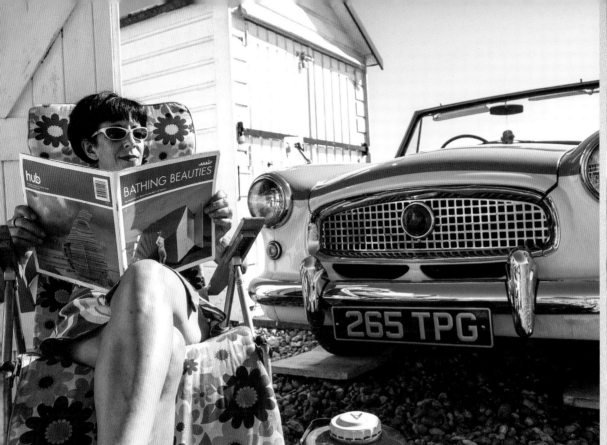

'Mishmashmepompom, nicknamed so because friends deliberately struggle with Nash Metropolitan, is a keeper. I love my car; it's part of me – even if people don't know me they're likely to know my car. It's become synonymous with me; we go together like fish and chips. And go together we do, to many '50s and '60s-inspired events that satisfy my love of music and dancing. These occasions go hand in hand with classic cars, thus friendships have formed with groups such as the Vultures, "The world's most useless car club" – our club tagline, not mine. Their ethos, like mine, is: Do your own thing and don't pander to purists. Therefore the Nash has been pinstriped and lowered – it's all personal preference, in other words it's been Myiafied. I consider the Nash to be much like my own persona – a mishmash of what I truly love.'

cadillac eldorado

'In the 1950s a Ford Model B Coupé with a flathead V8, from the breakers yard, would set you back £20. I'd smoke them around Walthamstow and drive the police crazy,' explains Bulldog Bill, owner of this 1972 Cadillac Fleetwood Eldorado and previous custodian of a further seven Cadillacs plus countless other cars. It sounds like great fun, but perhaps was not terribly appealing to the fairer sex. 'A side effect of my first Cadillac was the magnetism it had with the ladies! As a bashful 20-year-old I may not have had the patter, but they weren't concerned – the car did the talking. I guess 50 years on I'm trying to recapture a dream of the times spent with that 1953 Cadillac convertible.

'Working on cars just came naturally; no formal training – just a love of cars, engineering and big engines. I look back at the one-off cars I've built with disbelief, questioning a) how I got the ideas and b) how I found the skills to build them. I even recycled three foot of scrapped Caddy into a radiogram – before hoicking it up 14 floors of tower block. All I've now got left is memories, photographs, a trusty Cadillac and what's left of my hair.'

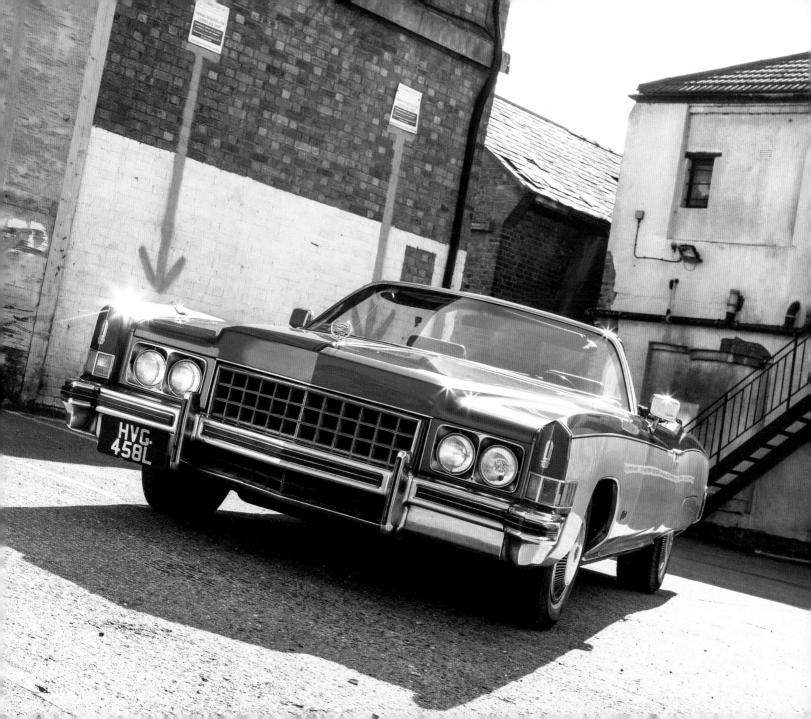

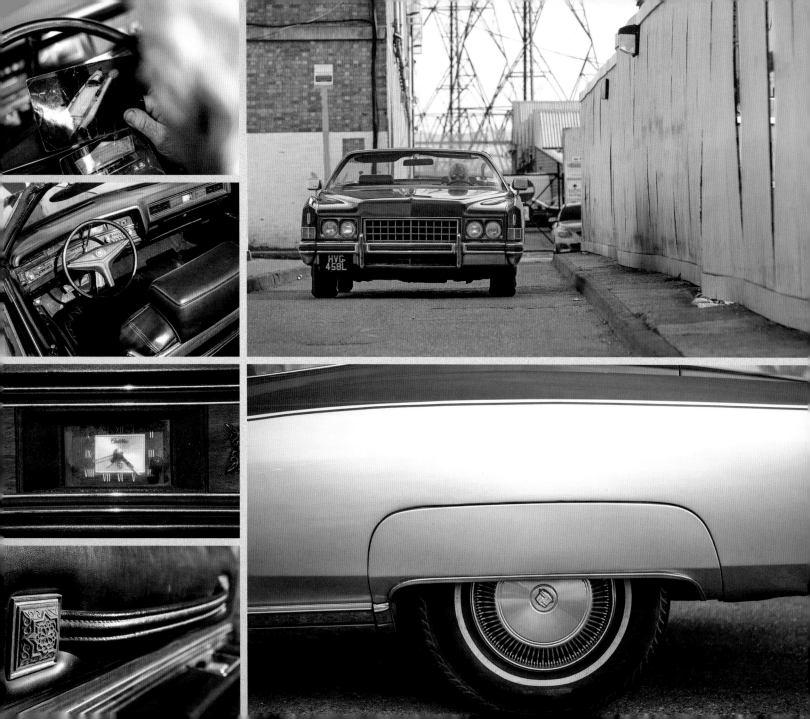

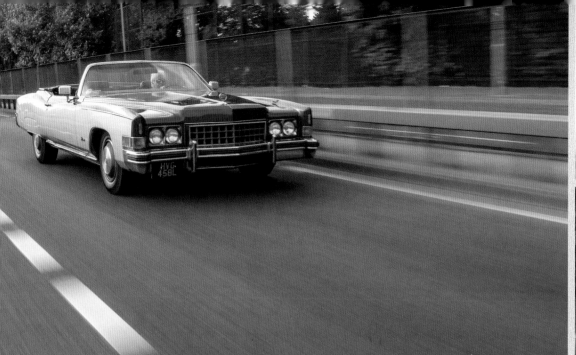

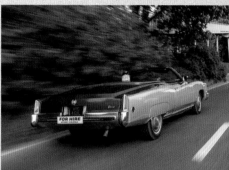

This seventh-generation Eldorado (1971–78) would both symbolise and mark the beginning of the end for gargantuan cars and oversized engines. In every way it was excessive, true to its name – *El Dorado* is Spanish for 'the golden one'. The bodyline's more refined, especially with the parade panel covering the dropped roof, when compared to earlier incarnations. Amid the plush interior there are intricate Aztec emblems (albeit wood-effect plastic) and buttons for everything.

'I bought this Cadillac in 2007. It was cheap; needed work, but nothing beyond my skill set. I was content to mosey about on my terms, until someone suggested I cash in on wedding car hire. Anything to supplement my lowly pension, I thought, so I painted it a lairy hue of pink and waited for the bookings. Sadly I got only a few jobs and once I'd paid out fuelling that 8.2-litre engine, that'd keep a hatchback going for a month, it wasn't worth it. Nor was it worth tolerating the grief from those shouting obscenities as I drove around town – before long I switched colour scheme.

'I love this car, but the future of the garage in which my car's stored is in jeopardy. If development plans go ahead, my car will be on the streets. They don't build parking bays for 19ft (5.8km) of car. Besides that, the damage it will probably endure and the hefty parking permit might result in me getting rid of the car. I'm not giving up; however, it could sadly be the end of an era.'

simca océane

'While everybody was seemingly buying Ford Anglias and Minis, I made do with a £12 1959 Simca Aronde. It very nearly put me off owning another; every time I'd venture out, I'd need towing back. That was until I had an altercation with a bridge. The impact must have given the car a much-needed wake-up call; from that day forth it never missed a beat. My admiration for these rugged cars, which appreciated being driven hard, grew. By 1985 I'd owned a string of Simcas; mainly Arondes, which coincidentally were the French company's first independent design.

'Simca dealers were scarce in the UK; however, Carmarthenshire, Wales, was a hotbed of Simca activity. On one occasion, when I swung by my local dealer for a browse, they'd a 1959 two-seater Océane convertible based on the Aronde floorplan. The Océane, with a body by Facel, had many characteristics of the Ford Thunderbird – including a fashionable wrap-around "panoramic" windscreen. It was more than coincidence; Simca hoped the car would carve its own niche in the American market. As much as I wanted it, I could neither afford nor justify £3,500 on yet another car,' explains Dick, owner of this Aronde (meaning 'swallow' in Old French).

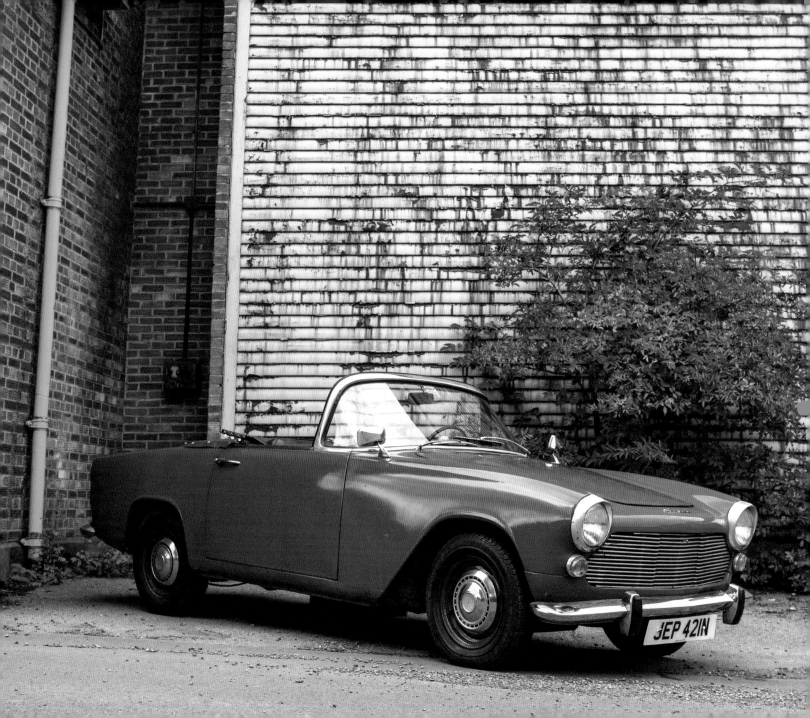

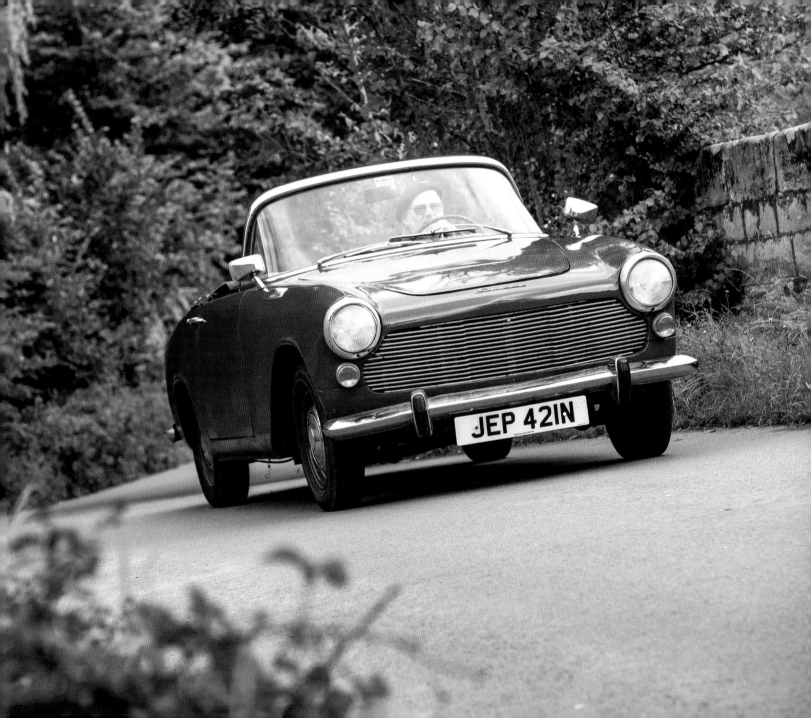

'It was never destined to be a cheap car; styling from Facel, plus engineering ingenuity and intricacies, increased the list price. A hefty purchase tax, resulting in the Océane costing more than a Jaguar, prohibited importation into the UK – hence the small numbers that exist here. By 1998 I was a Simca aficionado and president of the UK club, meaning I'd occasionally get calls informing me of Simcas in need of rescue. One such call was regarding a '70s Simca that the owner needed selling sharpish to raise funds for his wedding. When I arrived it wasn't what I expected; instead it was a '50s Simca – the exact same Océane I'd turned my back on years before. The confusion arose due to the car being freshly registered when it arrived in England in 1974. The seller was far from complimentary about his car, reeling off a list of faults and quibbles. However, once I'd bought the car for £350 (a tenth of the 1985 price) I found the issues were easily fixed; most were down to human error surrounding the mechanics.

'To this day it's been a regular drive, resulting in its condition best being described as "used". I don't have a cleaning routine – just a quick blast with the workshop airline. If it were restored, I'd be hesitant about using it. That would curtail my trips to France where, even though I speak a little French, the car does the talking – such is the love the French still bestow on the marque.'

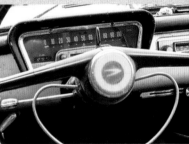

ford model a

'By the late 1940s cars such as the Ford Model A, successor to the Model T, were in abundance and choking scrapyards. So it was little surprise that three lads from San Jose, California, wielding acetylene torches set about modifying a 1930 Ford Model A Sport Coupé – chopping the roof and running boards and shortening the windshield to fashion a roadster. Just what they subjected it to is a mystery, but likely involved a dry lake bed; one thing for certain is that they trashed the engine. Having had their fun, and sooner than fix it, they just pushed it into a barn – where it remained from 1951 until 2008.

'I first learned of the roadster in 2011 after a night of eBay browsing. Its naturally aged patina, rod brakes and front mudguards (formed by slicing in half the spare wheel guards) were major attractions. The starting bid was $125; but rather than appear eager I waited until the morning – by which time the bidding had reached $7,500. That was the end of it; the price looked like it was heading way beyond my reach – or so I thought. That evening I despondently checked the bidding activity, only to find a buy-it-now price of $8,900,' explains John, who has

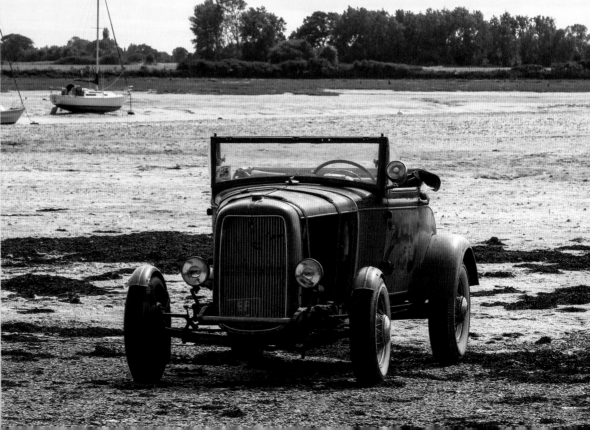

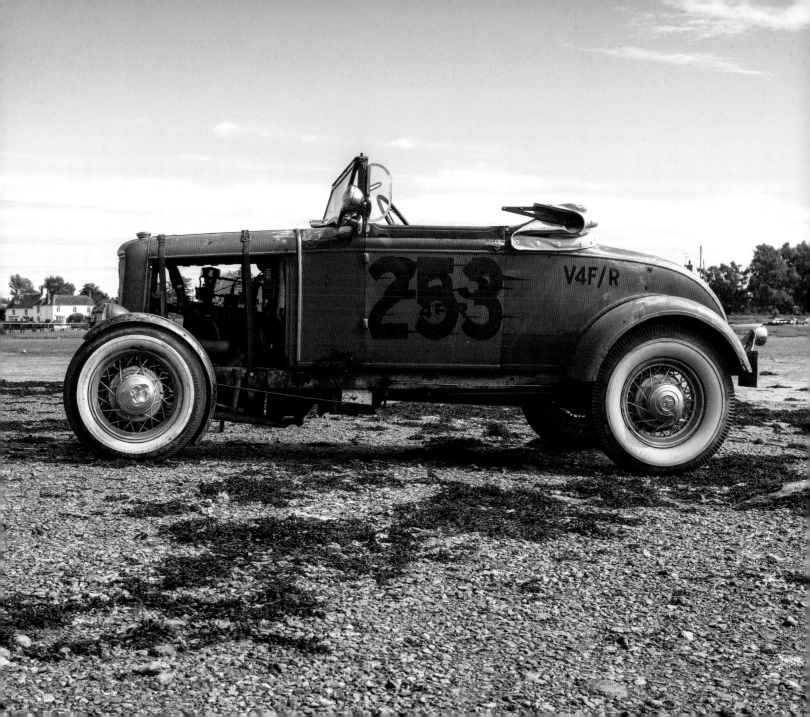

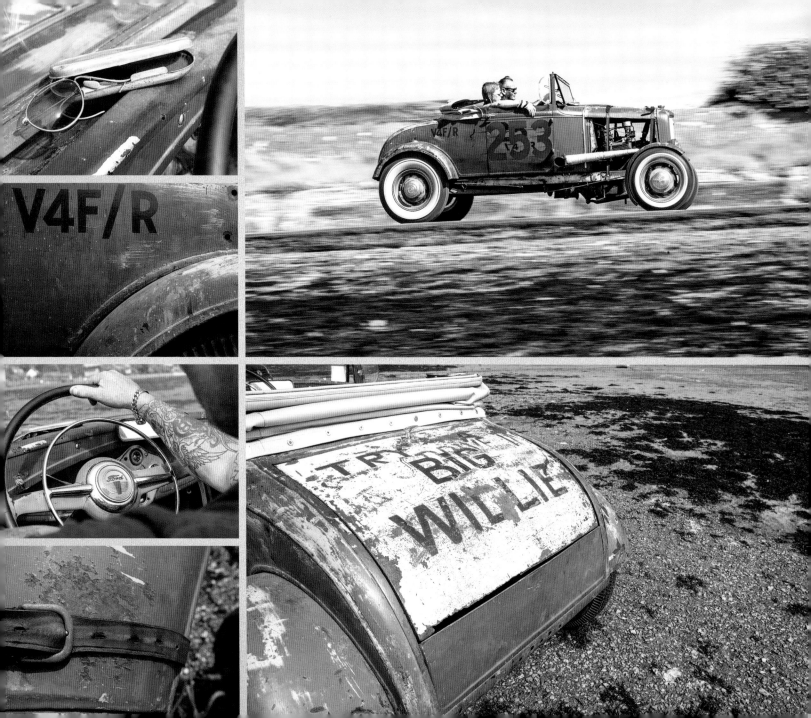

V4F/R

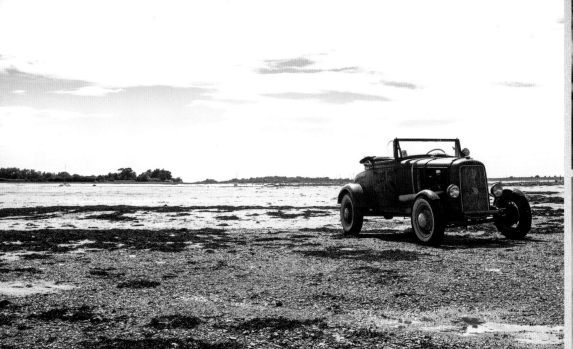

been immersed in the Rockabilly subculture from his twenties to the present day, hence his developing an appreciation of American cars.

'I hurriedly rang the seller in Dallas, Texas, and discussed the car at length – his love of cars was evident. Richard was his name, Richard Rawlings – to many that name will ring bells with Gas Monkey Garage and the TV series *Fast N' Loud*. However, the series hadn't yet aired in the UK and I was blissfully unaware of who I was dealing with – not that he was looking for his ego to be fed, far from it. He explained that he wasn't the first owner since 2008; it had changed hands a few times since being dragged from the barn, including a stint stored at the SO-CAL Speed Shop. I'd heard enough; the car was too good to pass up. A deal was done and shipping arranged.'

In the mid-1920s Ford's dominance of the automotive market, with the Model T, was being eroded by competitors. The threat was recognised and a replacement to the T put in motion. The Model A was produced from 1928 and was the second huge success for the company with 4,858,644 built. Today it's a converted car among the rodder community.

'It's something unique; it attracts so much attention. I'm reluctant to do too much to the car. Aside from replacing a few parts that went walkabout during shipping, I've done very little: new roof; hood straps; spotlight and side wind deflectors – but whatever I do, it's gotta be sympathetic to how it was found.'

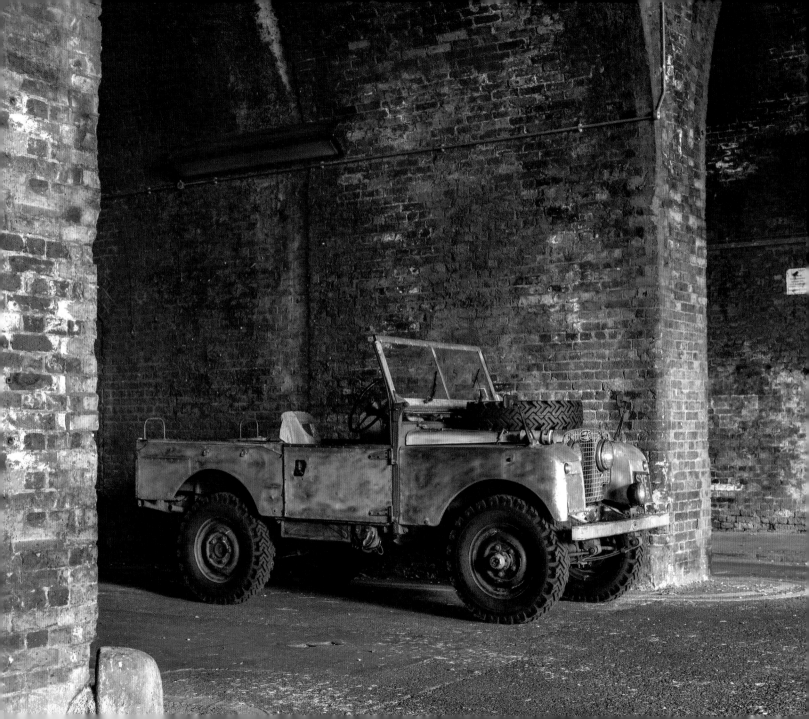

'I'm not what you could refer to as a fan of Land Rovers per se – just mine. And as first car choices go it's not typical. But I like to work on and obsess over the inner workings of machines – something modern automobiles just can't fulfil. Old doesn't mean obsolete; driving SXF around London with the roof off is as rewarding, if not more so, as any present-day vehicle. Granted, it's too high-maintenance for many and I admit adequate locks and heating would be nice, yet if achieving that means buying something modern, then I'm happy to forgo them. It's a tad free-spirited, but not too out there, for me to shun the notion of restoring for the sake of originality. Instead it should be for yourself; what you want to do to make it your own – a distinct and ongoing art project,' explains Jack, London-based coffee roaster and owner of this mid-'50s Land Rover Series I.

The adaptable and durable Land Rover was launched in 1948. The concept was formulated only the previous year to compensate for a post-war fall in production, as well as to satisfy the ego of Maurice Wilks, Rover's chief designer. He boasted that if he couldn't build a more superior off-road vehicle than the Willys Jeep, then he shouldn't be in business. Engineering **land rover**

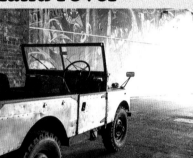

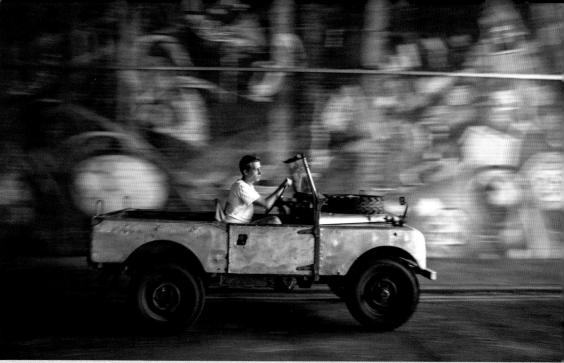

simplicity was key; a high-torque 1.6-litre engine and a gearbox fitted with a transfer case and four-wheel drive. A shortage of steel led to the simple folded body panels being made of Birmabright, an aluminium derivative. First-year sales of 8,000 easily topped the target of 5,000.

'I bought this ex-civil defence Land Rover about four years ago from my mate Alfie. Having heard I was in the market for one, he offered me his for gratis. It was a kind gesture that many wouldn't have turned down, but I preferred money to change hands – especially as he then couldn't ask for it back! Having stripped the body panels back from red oxide to bare metal, added personal touches and many mechanical improvements, I think it may be a day Alfie regrets, as he's asked for first refusal if I ever decide to sell it.

'It's had its fair share of quirky faults – some more obvious to fix than others. Such as when my Land Rover started indicating of its own free will – causing bedlam and much embarrassment. I thought I'd checked everything, until I dismantled the indicator switch and found an earwig, still alive, that was shorting the electrics and causing an earwig-based GPS.'

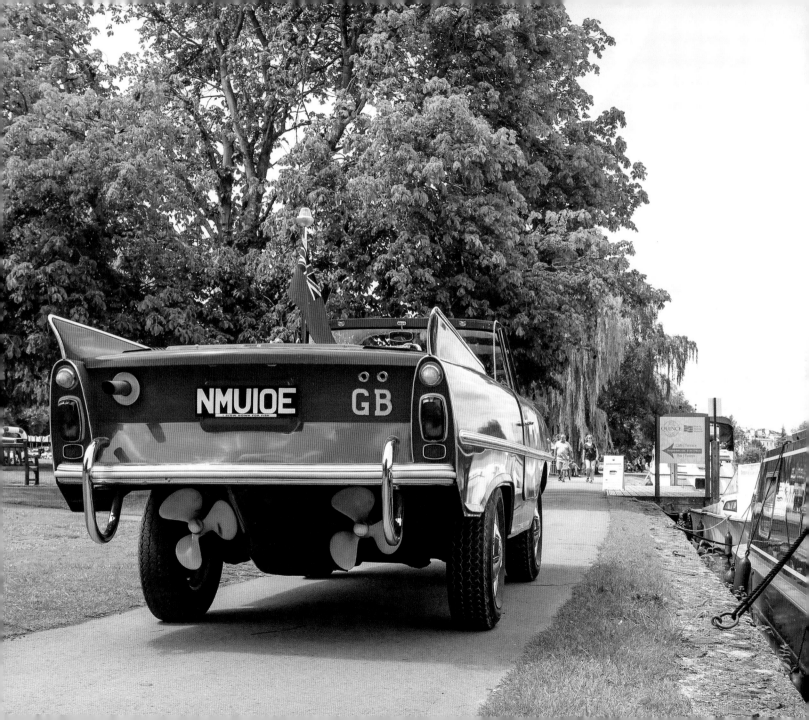

'Justifying a classic car when you've a company car and free petrol was difficult. However, I could justify a boat, which just so happened to incorporate a classic car – or vice versa. It wasn't long before I received a reply to my classified advert for an Amphicar. This was 1985 and there was no looking back for me – it was everything and more I wanted. A few years later I was even asking my wife whether we could return early from our honeymoon, so I could attend an auction for another dilapidated, but right-hand drive, Amphicar. Luckily I'd married an understanding lady and my request was granted. Three years and 52 square feet (4.8sq m) of new steel later my Amphicar was insured, MOT'd for both land and sea (for which it's registered as a 14-ft/4.25m inland motor cruiser) and ready for her maiden voyage. Aside from the usual, this is the only car where you'll find propellers, bilge pumps, navigation lights and, for fun, a depth gauge – handy on our wee trip to Loch Ness. The Amphicar is from the same generation of designers that brought us Concorde, the hovercraft and the Space Race. An era of belief that with the right engineering anything is possible,' explains David, owner of this iconic and head-turning vehicular vessel.

amphicar

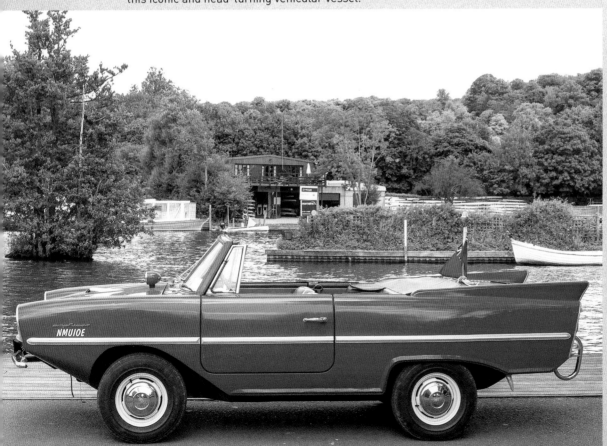

NMUIOE

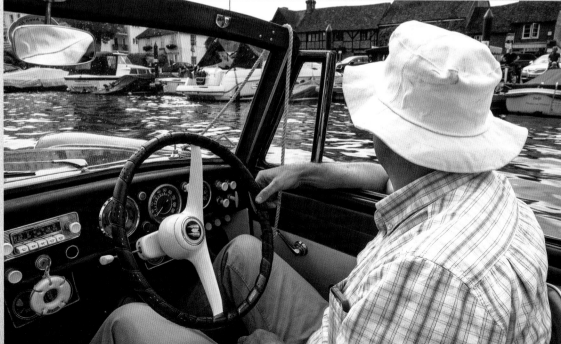

AMPHICAR

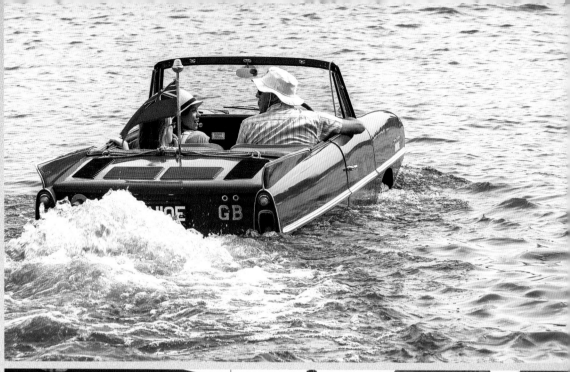

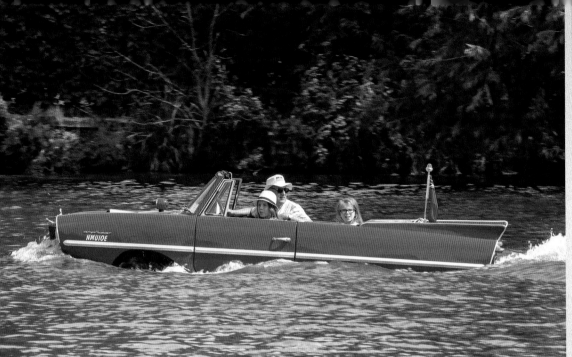

They were designed and built by the German Amphicar Corporation, part of the Quandt Group who owned BMW, which planned to build something they could sell to America. They'd a proven track record in building amphibious vehicles, so commissioned a civilian version. They called upon industrial designer Hans Trippel to take the helm but, being a fastidious man, he wouldn't be rushed. Despite the project starting in the early '50s it was 1962 before it was ready to be launched in Florida. The delays were ultimately its demise. Automotive styling had changed and marketing was poor – it missed the boat. Plans for 20,000 units a year were hopelessly optimistic and a total of only 3,878 were produced. It's thought that only 400 of these wonderfully eccentric vehicles remain.

David and his car remain a familiar sight in his home town, where he's a local hero after the events of Friday, 20 July 2007. David continues: 'After heavy rain the two rivers that converge at Tewkesbury burst, flooding the surrounding streets. I received a slightly flustered call from my sons who, along with 500 hungry children, were trapped at the local school. Like a scene from a Gerry Anderson series I fired up the Amphicar and leapt into action. At a top speed of 8 knots, dodging upturned shopping trollies, I docked at the doors of the local supermarket. Fully laden with supplies I undertook five trips that lasted well into the night – the news of my escapade went global.'

ford cortina

'In my eyes the Mk3 Ford Cortina will always be my favourite. When I bought this in 1985, aged 21, it was already my second Mk3 and my fifth Ford. To raise the funds I had to go cap in hand to the bank and take out a loan. However, for a Mk3 convertible I would have done anything, within reason, to own one. It was only when viewing it that I was informed of its history; being the doctor's car at Santa Pod Raceway in Northamptonshire – Europe's first permanent drag racing venue. If the need arose the doctor would head off through the tyre smoke to administer medical assistance. With my love of straight-line speed and Pro Street cars (street-legal custom cars popular during the 1980s) its history gave it even greater appeal,' confesses Richard, owner of this high-powered Crayford conversion.

'It wasn't long before I did away with the two-litre engine for a three-litre V6, but quickly got bored and swapped it for a 3.5-litre Rover SDi V8 engine. This, along with a host of other uprated mechanicals and nitrous oxide system makes my Crayford Cortina the fastest out there. This level of tinkering wasn't unusual; I'd been doing it since my first 50cc moped. However, everything I undertook, including the paintwork, had to be completed within the confines of a lunch hour or weekend; it was, after all, my everyday car. As you can imagine,

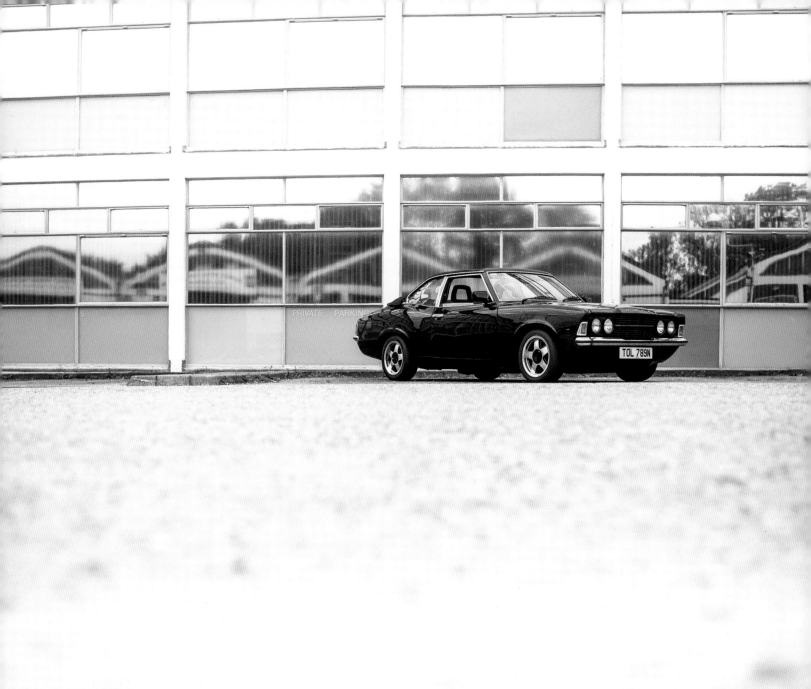

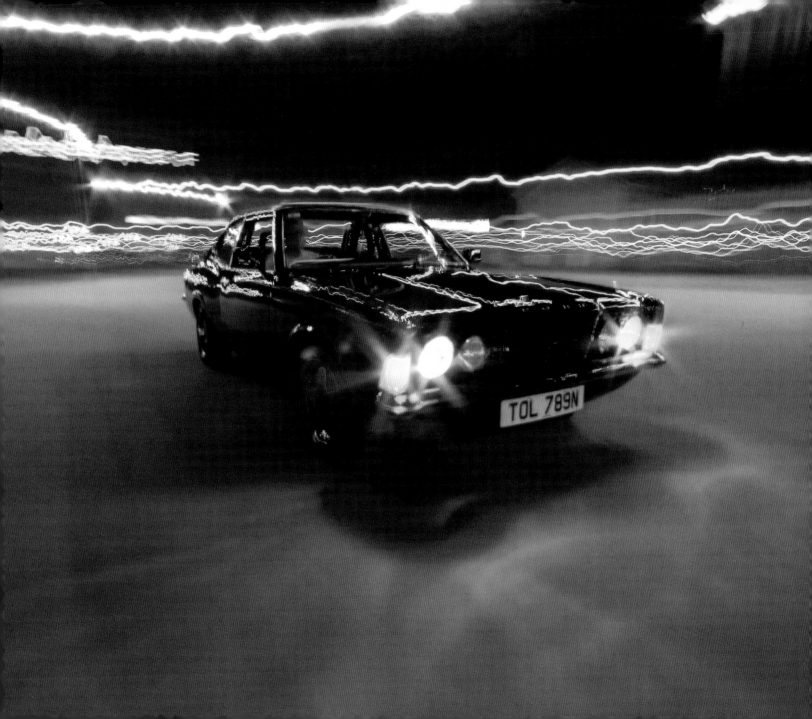

I was happy as a pig in the proverbial when a local airfield starting holding drag racing events – I was one of the first at the gates!'

The Mk3 Ford Cortina (1970–76) capitalised upon the popular North American Coke-bottle styling of the '70s era. Crayford Engineering (who carried out the Heinz 57 Hornet conversions we saw on page 25) were founded in 1962, specialising in converting European coupés and saloons into convertibles and estates. They were keen to repeat the successes of their Mk2 Cortina convertible – their best seller to date. Instead of being labelled as a convertible, the conversion was marketed as a Sunshine Conversion; a full-length roof that retracted yet retained its side windows in order to maintain upper-body strength. Over 400 such conversions were made.

'I never had the benefit of a father to work alongside me; my old man died when I was 11. Even my local polytechnic turned me down, blaming my below-average qualifications. Everything I've learned in regards to mechanics is the result of getting stuck in and finding out, which is why I'm helping my son, Craig, with the restoration of his Mk3 Capri in any way I can. The apple, as you can see, didn't fall far from the tree in respect to his love of Fords.'

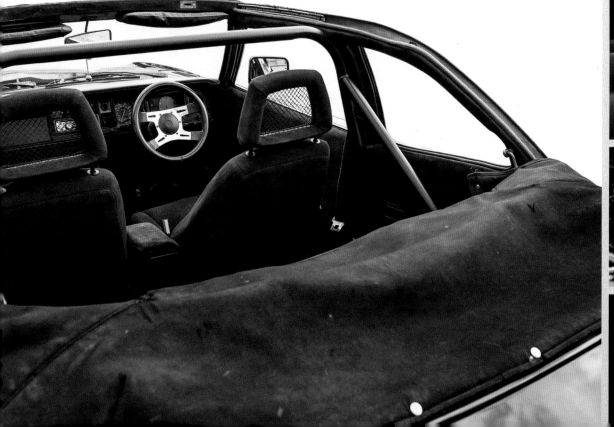

sourcebook

owners clubs

Alfa Romeo
www.aroc-uk.com

Amphicar
www.amphicars.com

Aston Martin
www.amoc.org

Beach Buggy
www.manxmaniac.co.uk

Bristol
www.boc.net

Cadillac
www.cocgb.dircon.co.uk

Corvettte
www.corvetteclub.org.uk

Crayford
www.crayfordconvertibleclub.com

Daimler SP250 Dart
www.daimlersp250dartownersclub.com

Ford Consul
www.mk2consulzephyrzodiacownersclub.co.uk

Frazer Nash-BMW
www.frazernash.co.uk

Gamine Vignale
www.mixe.demon.nl/gamine/gamine_
links.htm

Honda S800
www.hondas800sportscarclub.co.uk

Jaguar XJ-S
www.xjsclub.org

Karmann Ghia
www.kgoc.org.uk

Lagonda
www.lagondaclub.com

Land Rover
www.lrsoc.lpl-uk.com

Lotus Elan
www.lotuselansprint.com

Mercedes-Benz
www.mercedes-benz-club.co.uk

MG TC
www.mgownersclub.co.uk
www.mgtcownersclub.com

Morris Minor
www.mmoc.org.uk

Nash Metropolitan
www.metropolitanownersclub.co.uk

Peugeot
www.clubpeugeotuk.org

Porsche
www.porscheclubgb.com
www.914club.com

Reliant Scimitar
www.reliantownersclub.co.uk

Renault
www.renaultownersclub.com

Saab
www.saabclub.co.uk

Simca
www.simcatalbotclub.org

Skoda
www.skodaowners.org

Studebaker
www.studebakerownersclub.org.uk

Talbot
www.simcatalbotclub.org

Triumph
www.tr7.co.uk

TVR
www.tvr-car-club.co.uk

Vauxhall
www.mk2cav.com

Volkswagen Golf
www.vwgolfmk1.org.uk

Westfield
www.westfield-world.com

Wolseley
www.wolseleyownersclub.com

car sales

Claremont Corvette
Corvette sales, service and parts
www.corvette.co.uk

Frank Dale & Stepsons
Rolls-Royce and Bentley sales
and servicing
www.frankdale.com

Dream Cars
Classic American cars for sale
www.dreamcars.co.uk

Eclectic Cars
Eclectic car sales and
classic car servicing
www.eclecticcars.co.uk

car hire

Classic Car Club
www.classiccarclub.co.uk

Classic Car Hire
www.classiccarhire.co.uk

museums

**Beaulieu National
Motor Museum**
www.beaulieu.co.uk

Brooklands Museum
www.brooklandsmuseum.com

Haynes Motor Museum
www.haynesmotormuseum.com

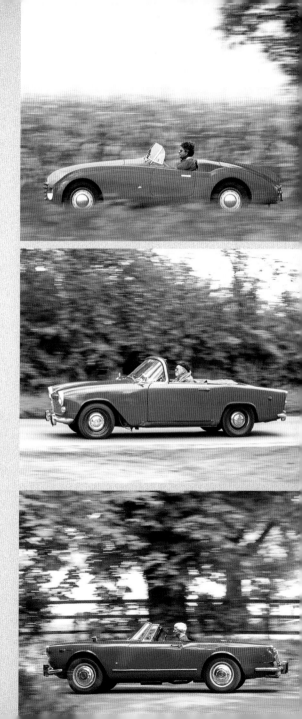

credits

We would like to thank all the owners for allowing us to photograph their 'cool convertibles'.

All photography by Lyndon McNeil unless otherwise stated.
www.lyndonmcneil.com

treasured

Pages 12–15	Delilah, Colin Frost, Kent
Pages 16–19	Simca Studebaker, Richard Pratt, Oxfordshire
Pages 20–21	Sprint, Carl Pereira, St Neots, Cambridgeshire
Pages 22–24	Artorius, Chris Parkhurst, Buckinghamshire
Pages 25–27	Hornet Soup, Bill and Kate Bell, Merseyside
Pages 28–31	Happy Caddy, Stewart Homan, Surrey
Pages 32–35	Josephine, James Mann, East Sussex
Pages 36–37	Gamine Vignale, Sheridan Bowie, Kent
Pages 38–39	Honda S800, John Tetley, Cheshire
Pages 40–41	Renault Caravelle, Fred Parker, East Sussex

exemplary

Pages 44–45	Rolls-Royce Phantom II Continental, David Morgan, Hertfordshire
Pages 46–49	Karmann Ghia, Martin Fulwell, Staffordshire
Pages 50–53	Win Percy, Dorset
Pages 54–56	Mercedes-Benz 380SL, Samuel Cise, Surrey
Pages 57–59	Alfa Romeo, Ian Packer, Buckinghamshire
Pages 60–63	Frazer Nash-BMW 328, Gary Pusey, Hampshire
Pages 64–65	Ford Consul, Reg Wernham, Oxfordshire
Pages 66–69	Corvette, Dieter Orton, Surrey
Pages 70–72,	Jaguar XJ-S, Tom Pegg, London
Pages 73–75	10DPG, Geoffrey Herdman, Herefordshire
Pages 76–79	Aston Martin DB6 Vantage Volante, David Richards CBE, Warwickshire
Pages 80–83	The Collector, Daniele Turrisi, Italy

evocative

Pages 86–88	Wedge, Darren Hartman, Essex
Pages 89–91	Vauxhall Cavalier, Tomas Kaloczi, Hertfordshire
Pages 92–95	California Dreamin', Andy Talbot, Merseyside
Pages 96–98	Skoda Rapid, Colin Iles, Wiltshire
Pages 99–101	TVR 450 SEAC, Andy Hutcheson, Cambridgeshire
Pages 102–104	The Bean, Toby Restorick, Cheshire
Pages 105–107	Reliant Scimitar SS1, Philip Andrew, Berkshire
Pages 108–109	The Family Way, Richard Bone, Birmingham
Pages 110–113	Peugeot 304, Mark and William Bray, Hampshire
Pages 114–117	Talbot Samba, Terry Curtis, West Sussex

individual

Pages 120–123	Westfield Eleven, Chris Todd, Surrey
Pages 124–127	Beach Buggy, Peter Gibb, Kent
Pages 128–131	Mishmashmepompom, Myia Hancox, Surrey
Pages 132–135	Cadillac Eldorado, Bill Thompson, Essex
Pages 136–139	Simca Océane, Dick Husband, West Midlands
Pages 140–143	Ford Model A, John Dewhurst, Hampshire
Pages 144–147	Land Rover, Jack Coleman, London
Pages 148–151	Amphicar, David Chapman, Worcestershire
Pages 152–155	Crayford Cortina Mk3, Richard Wood, Essex

Additional captions: page 1 corvette; pages 2–3 10dpg; page 4 the collector; page 6 josephine; page 9 amphicar; page 10 sprint; page 42 frazer nash-bmw 328; page 84 tvr 450 seac; page 118 beach buggy; page 157 (from above) the collector, simca océane and alfa romeo; page 160 frazer nash-bmw 328.

acknowledgements

It honestly doesn't seem long ago that I was waiting, with bated breath, for the first reviews to appear for *my cool caravan*. So as ever, when it comes to writing the acknowledgements, I must express heartfelt thanks to the loyal followers of the *my cool...* series. Without your continued support and that of Fiona Holman (my commissioning editor at Pavilion Books), I wouldn't now be finalising title number seven; who'd have thought it?

I'd like to express my gratitude to all the owners of the wonderful vehicles that appear in this book. You've been kind enough to accommodate last-minute adjustments to schedules, in order to make the best of the inclement summer we've experienced. As I've mentioned before on previous titles, without the enthusiasm from those who appear in the book, going above and beyond what's expected, the series wouldn't have been so rewarding and successful and one that I'm so proud to put my name to.

I'd like to dedicate this book to Lyndon McNeil. Colleague and friend; friend and colleague – whichever way round, he's proved to be an altogether top chap who's worked alongside me on my last five titles. Always delivers the goods; never grumbles; the definition of a true professional – we make a good team and here's to the future and whatever it might bring!

Lyndon and I hope that you enjoy the book as much as we've thoroughly enjoyed creating it.

mycool.com mycool.com mycoolclassic.com mycool.com
mycool.com mycool.info mycool.com

chris haddon
Chris Haddon is a designer with more than 20 years' experience. He has a huge passion for all things retro and vintage. Among his collection is a converted 1960s Airstream, which he uses as the studio for his design agency.

lyndon mcneil
Even during his school years, a camera was never far from Lyndon McNeil's reach. Since then he has found a photographic niche for all things wheeled and his work has graced the pages of the world's top motoring magazines. His keen eye for the perfect picture has been a true asset to the *my cool...* series.

First published in the United Kingdom in 2016 by
Pavilion
1 Gower Street
London WC1E 6HD

Copyright © 2016 Pavilion Books Company Ltd
Text copyright © 2016 Chris Haddon

Editorial director Fiona Holman
Photography by Lyndon McNeil
Styling by Chris Haddon
Design Steve Russell
Editor Ian Allen

ISBN 978-1-910-90430-5

A CIP catalogue for this book is available from the British Library

10 9 8 7 6 5 4 3 2 1

Reproduction by Mission, Hong Kong
Printed and bound by Toppan Leefung Printing Ltd, China

This book can be ordered direct from the publisher at
www.pavilionbooks.com

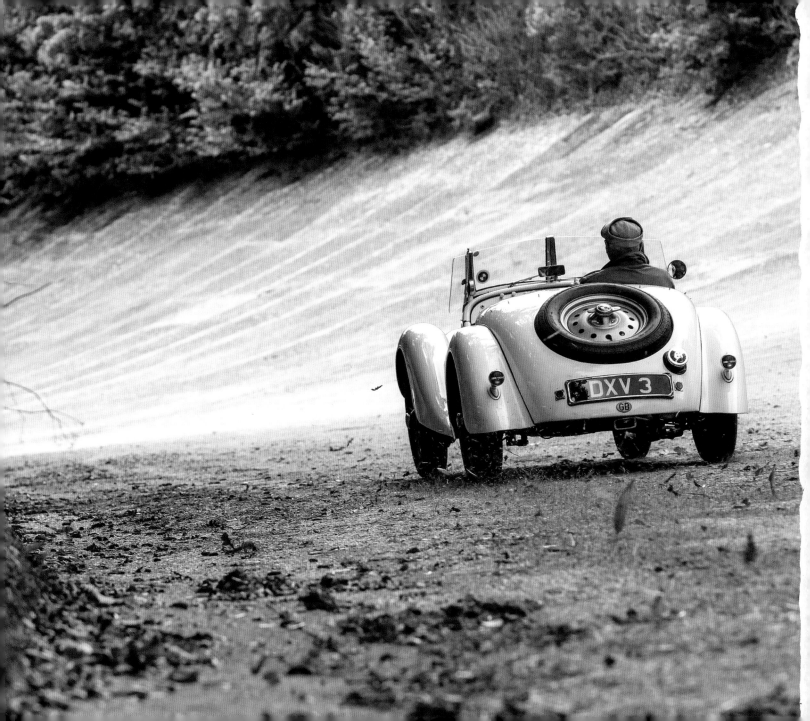